20 WAYS TO DRAW A TREE

AND 44 OTHER NIFTY THINGS FROM NATURE

ELOISE RENOUF

A Sketchbook for Artists, Designers, and Doodlers

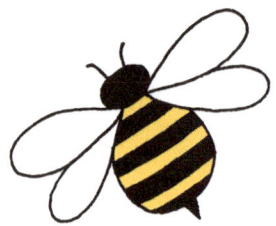

Quarto.com

© 2013 by Quarry Books

First published in 2013 by Quarry Books, an imprint of The Quarto Group, 100 Cummings Center, Suite 265-D, Beverly, MA 01915, USA.
T (978) 282-9590 F (978) 283-2742

EEA Representation, WTS Tax d.o.o.,
Žanova ulica 3, 4000 Kranj, Slovenia.
www.wts-tax.si

All rights reserved. No part of this book may be reproduced in any form without written permission of the copyright owners. All images in this book have been reproduced with the knowledge and prior consent of the artists concerned, and no responsibility is accepted by producer, publisher, or printer for any infringement of copyright or otherwise, arising from the contents of this publication. Every effort has been made to ensure that credits accurately comply with information supplied. We apologize for any inaccuracies that may have occurred and will resolve inaccurate or missing information in a subsequent reprinting of the book.

Quarry Books titles are also available at discount for retail, wholesale, promotional, and bulk purchase. For details, contact the Special Sales Manager by email at specialsales@quarto.com or by mail at The Quarto Group, Attn: Special Sales Manager, 100 Cummings Center, Suite 265-D, Beverly, MA 01915, USA.

ISBN: 978-1-59253-837-9

Digital edition published in 2013
eISBN: 978-1-61058-765-5

**Library of Congress Cataloging-in-Publication Data
Control Number 2012953779**

Design: Debbie Berne

CONTENTS

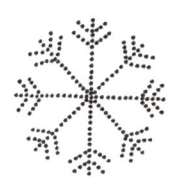

Introduction 4

Draw 20 . . .
Trees 6
Mushrooms 8
Birds 10
Stemmed Flowers...... 12
Ferns 14
Pinecones............... 16
Leaves 18
Acorns................... 20
Snowflakes 22
Berries 24
Herbs.................... 26
Snails................... 28
Feathers 30
Winter Trees........... 32
Daisies 34
Owls..................... 36
Beetles................. 38
Flowers................. 40
Clouds................... 42
Apples................... 44
Grasses 46
Tree Seeds............. 48
Eggs..................... 50

Shells 52
Logs 54
Stars 56
Nests.................... 58
Roses.................... 60
Fossils.................. 62
Blossoms 64
Stones................... 66
Twigs 68
Dragonflies 70
Tulips................... 72
Grains 74
Bees..................... 76
Seed Heads 78
Moths 80
Peacock Feathers..... 82
Caterpillars 84
Dandelions............. 86
Thistles 88
Butterflies 90
Root Vegetables....... 92
Citrus Fruits 94

About the Artist........ 96

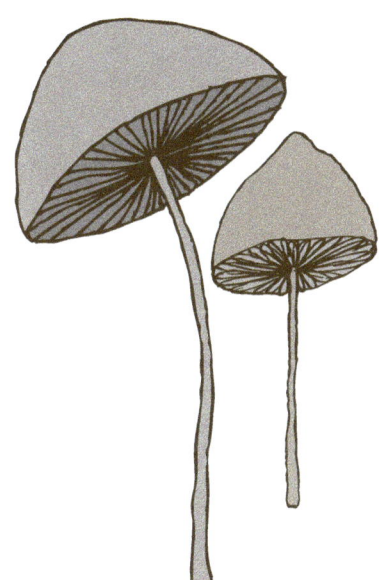

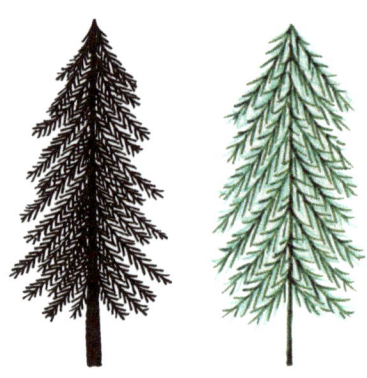

INTRODUCTION

20 WAYS TO DRAW A TREE is a fun and interactive book designed to help you explore a wide variety of approaches to drawing. It encourages experimentation with media and explores different ways of looking and seeing. Inside you will find plenty of examples to delight and inspire, and space to add your own creations.

Nature is a rich source of material for challenging and exciting things to draw. In this book, forty-five themes from nature have been chosen, with each drawn in a wide variety of styles. For each theme, the subject matter remains the same, but the approach to drawing it differs. You will see twenty ways to draw each topic: Perhaps you can come up with twenty more?

Drawing, in its most basic form, suggests the use of paper and pencil to capture or record a subject. We may be familiar with a certain way of drawing, but there are many ways we can "draw" that make use of a much broader range of materials, media, and techniques than we normally use. A fine-line pen will give clean, crisp, and controlled lines. A dip pen and ink will give a looser line that varies in weight. Painterly brushstrokes give energy and suggest movement. Paint spread on acetate and then scratched into before being pressed onto paper gives texture and depth. An edge of card dipped in paint and used as a printing tool gives random and unique marks. Each of these methods is effectively a way of "drawing" or recording the subject matter—but the results are dramatically different.

The way we "see" a subject also affects our drawing. Our focus may vary widely. Perhaps we are interested in shape, texture, line quality, or color? Maybe our focus is on the decorative elements of the object? When we draw, we are able to use our personal responses to the subject matter

to highlight, enhance, ignore, or omit certain aspects that we find particularly interesting or, alternatively, unappealing. For example, when we draw a tree, are we interested in the outline shape? Or is it the texture of the bark and leaves? Perhaps we are focusing on the repetition of the branches? Each time our focus changes, our drawn response changes, too.

HOW TO USE THIS BOOK

There are twenty drawings for each theme shown in this book. Some are very simple; some are more complex. Some are realistic while others are reduced to their most basic geometric elements. Some drawings are rendered accurately; others ignore scale and proportion. Some approaches are bold and angular while in contrast, others are soft and delicate. Look at the images and select those that interest you. What is it about them that pulls you in? Can you draw something similar? Can you improve on the image?

Some pages have been left blank for you to fill; others have spaces for you to draw between the images. Maybe the trees can be turned into a forest? Maybe the shells can treble in number? Perhaps the snowflakes will become a blizzard!

There are no right or wrong ways to draw. Just as we all have our own handwriting, everyone has their own hand with artwork—a unique way of making our marks.

Try not to be too self-conscious about the results. Some drawings will work, and others will be less successful. Enjoy the process and embrace happy accidents. Most of all, have fun, be playful, and try things out. There are many, many wonderful ways to draw a tree!

trees: colored marker
leaves: waterproof ink and watercolor
eggs: watercolor
acorns: watercolor and colored marker

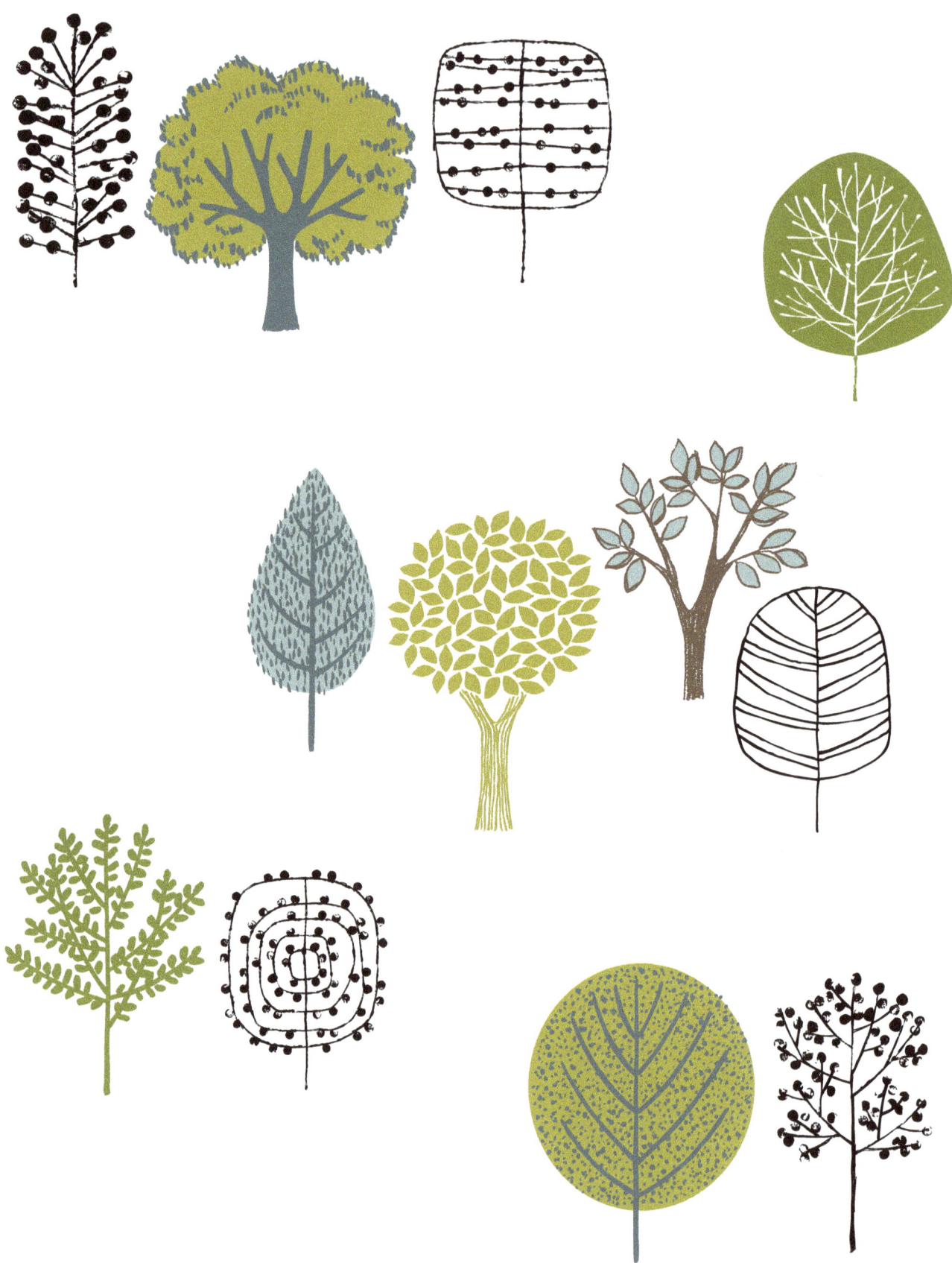

DRAW 20
TREES

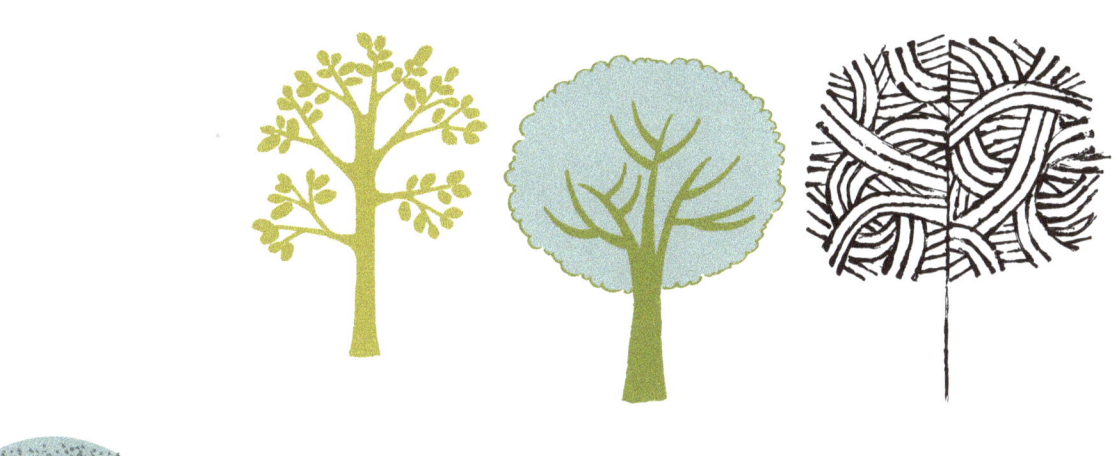
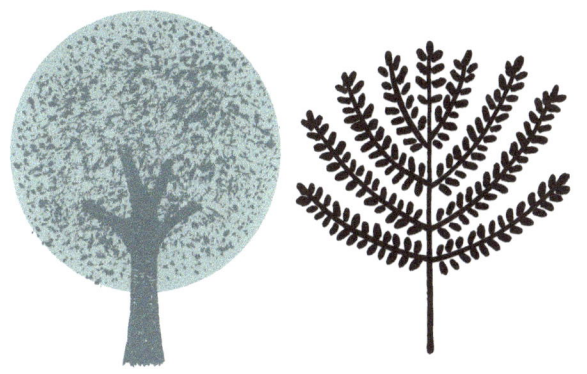
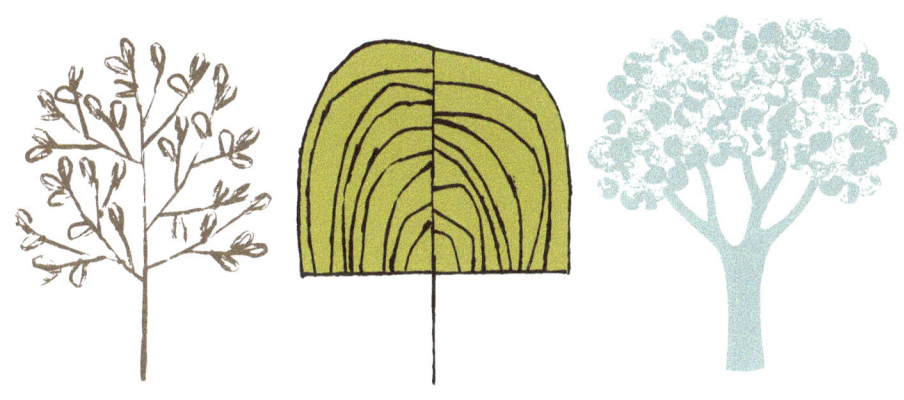

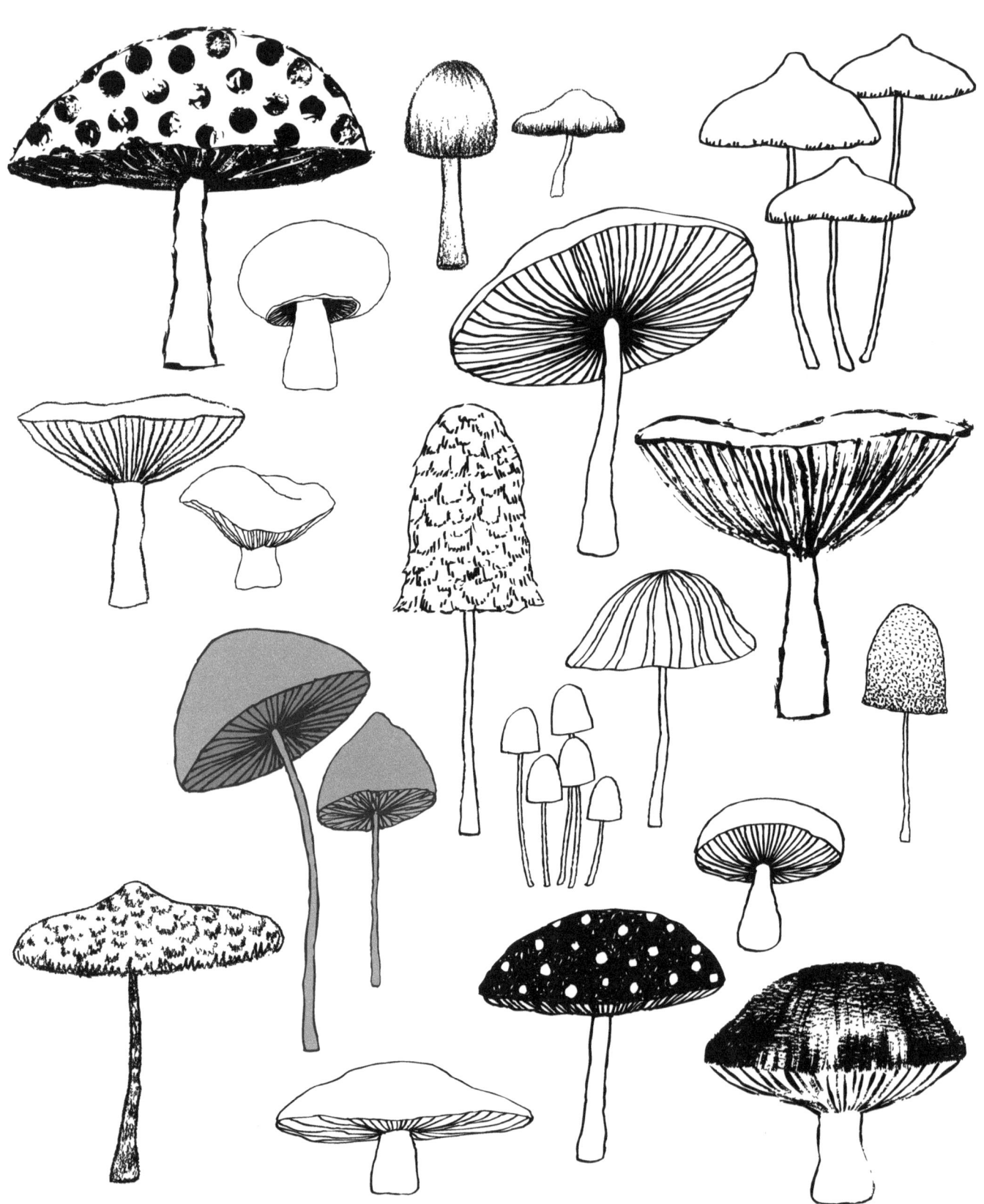

DRAW 20
mushrooms

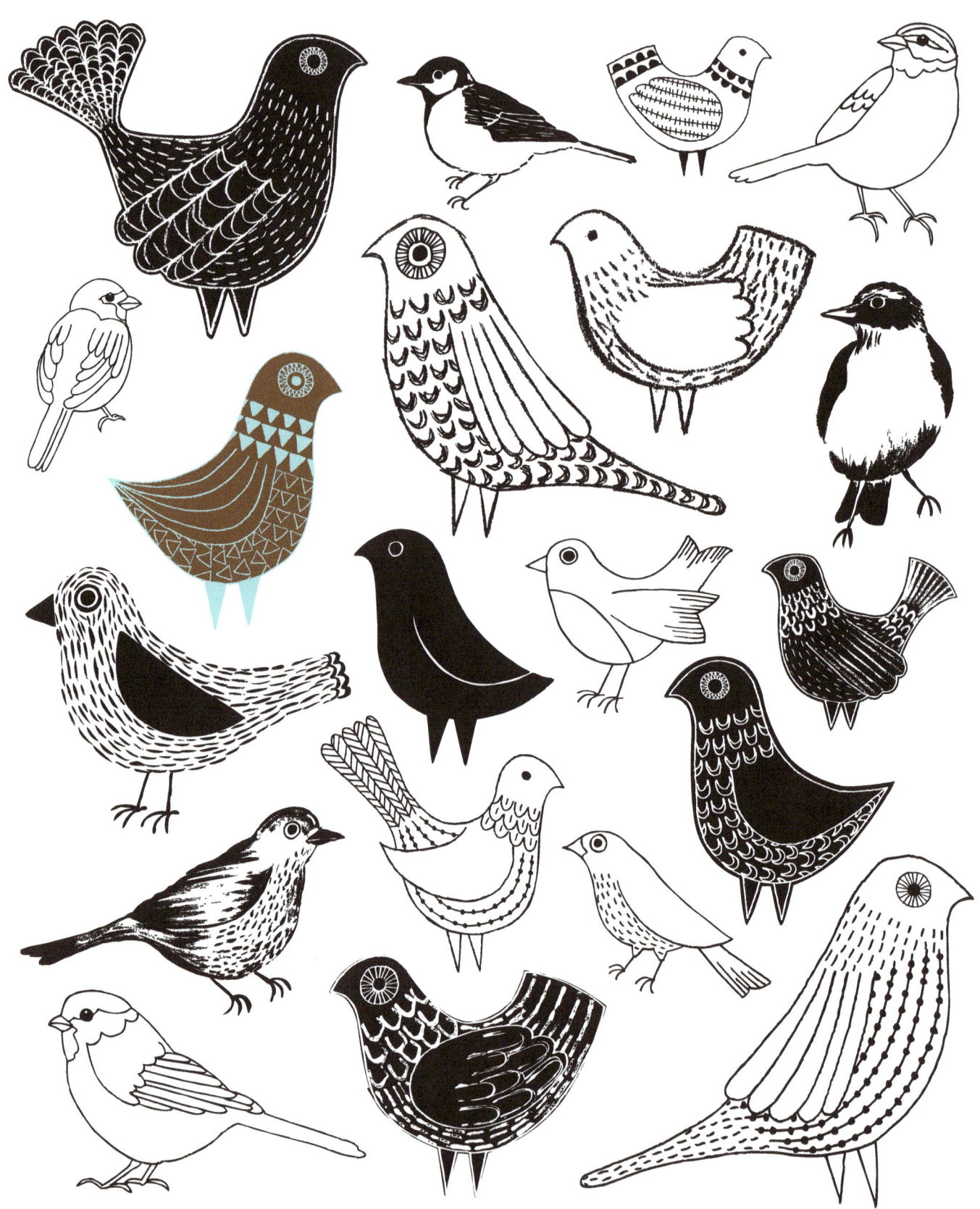

DRAW 20
Birds

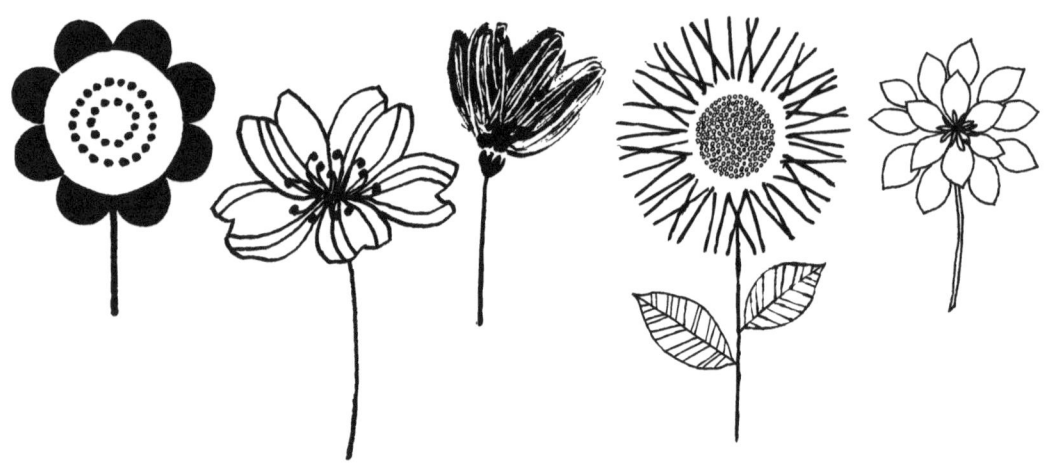
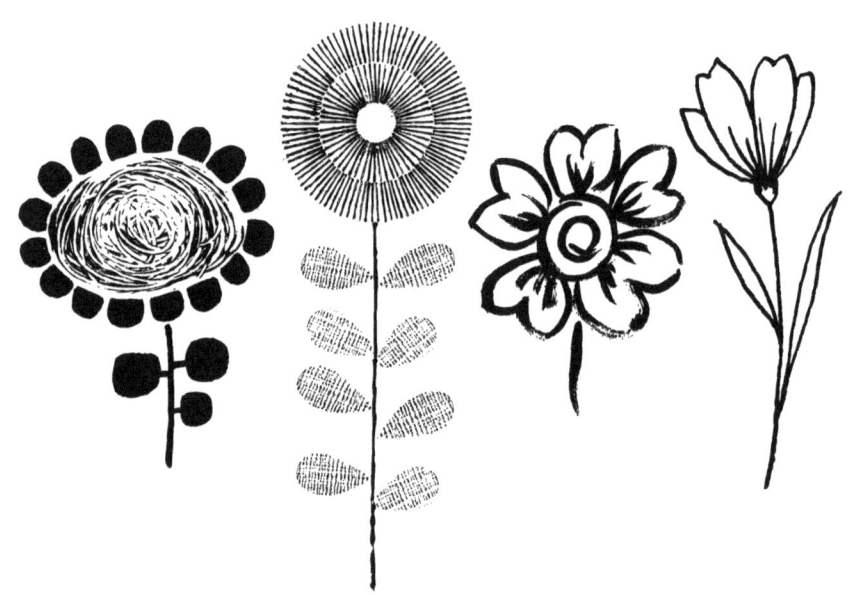
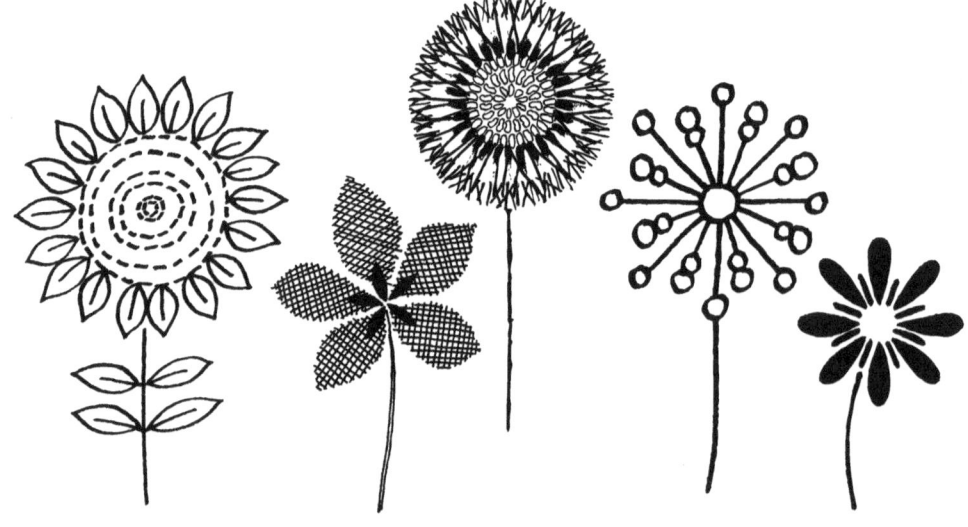

DRAW 20
stemmed flowers

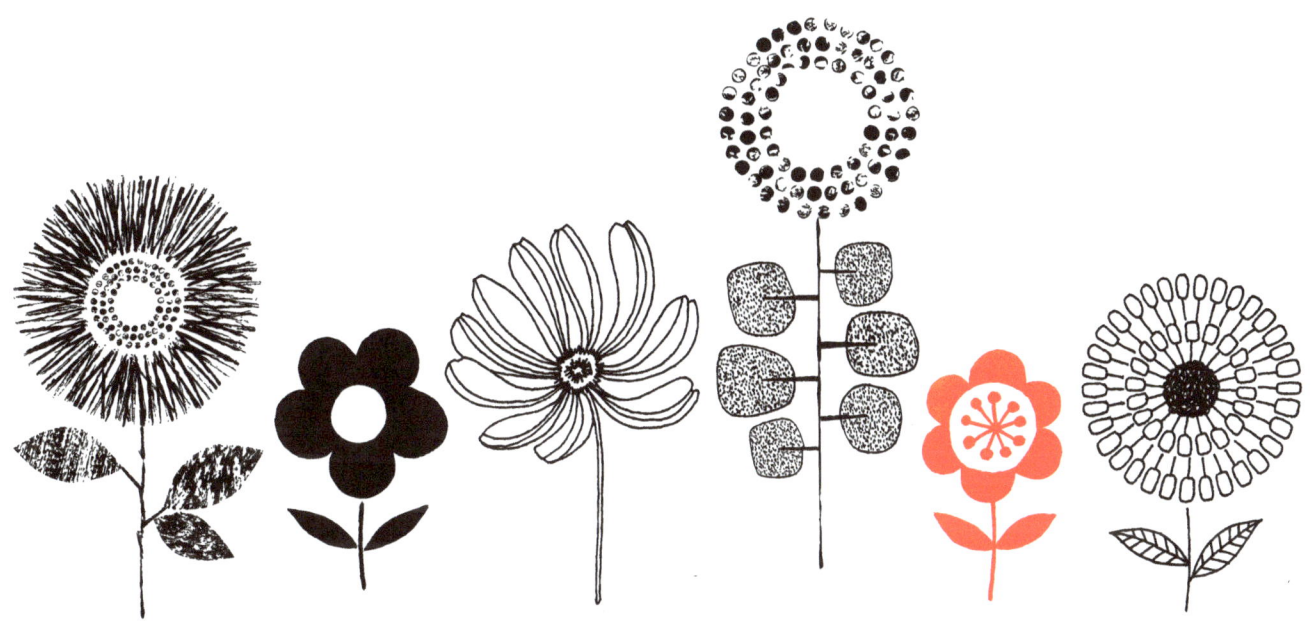

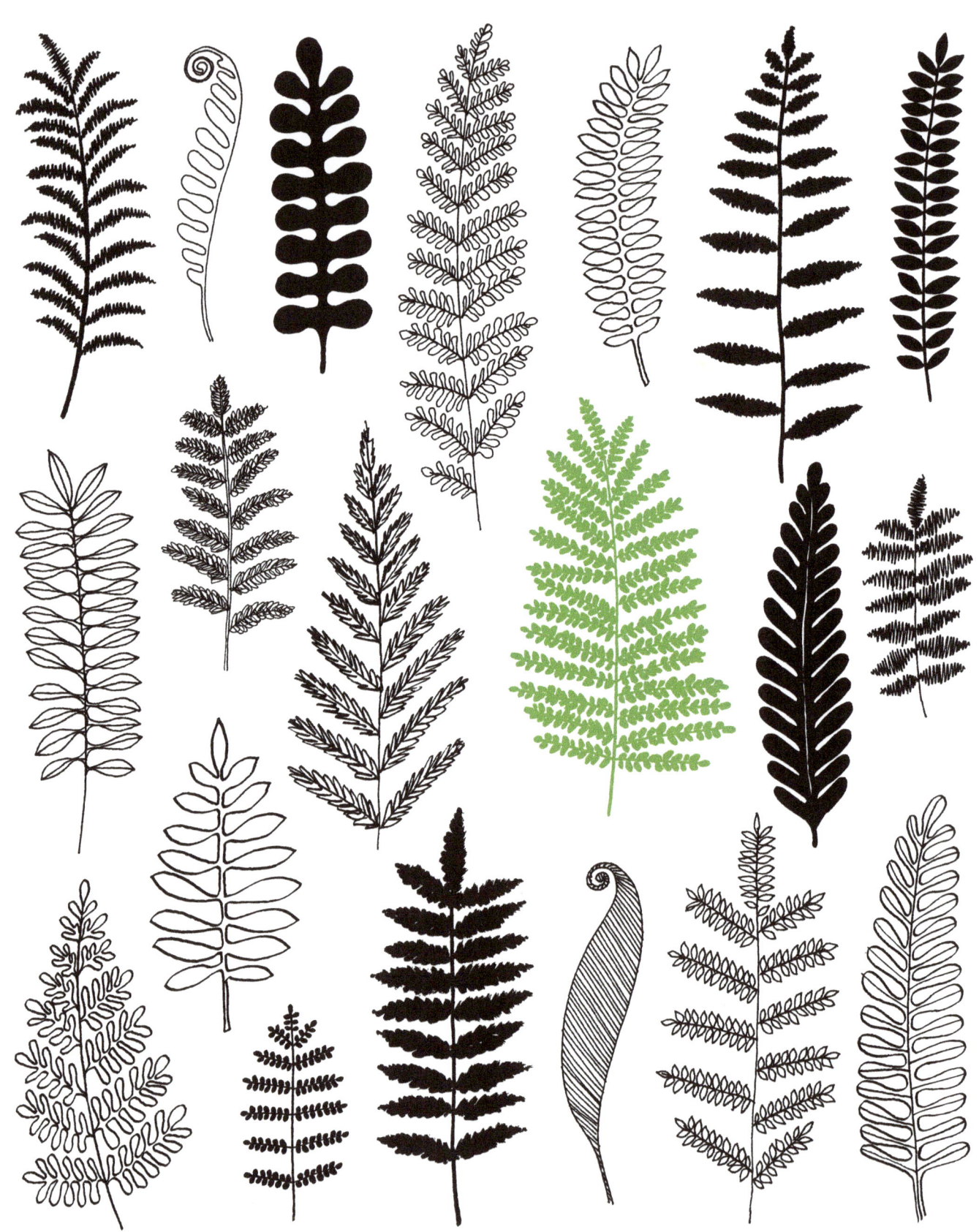

DRAW 20
Ferns

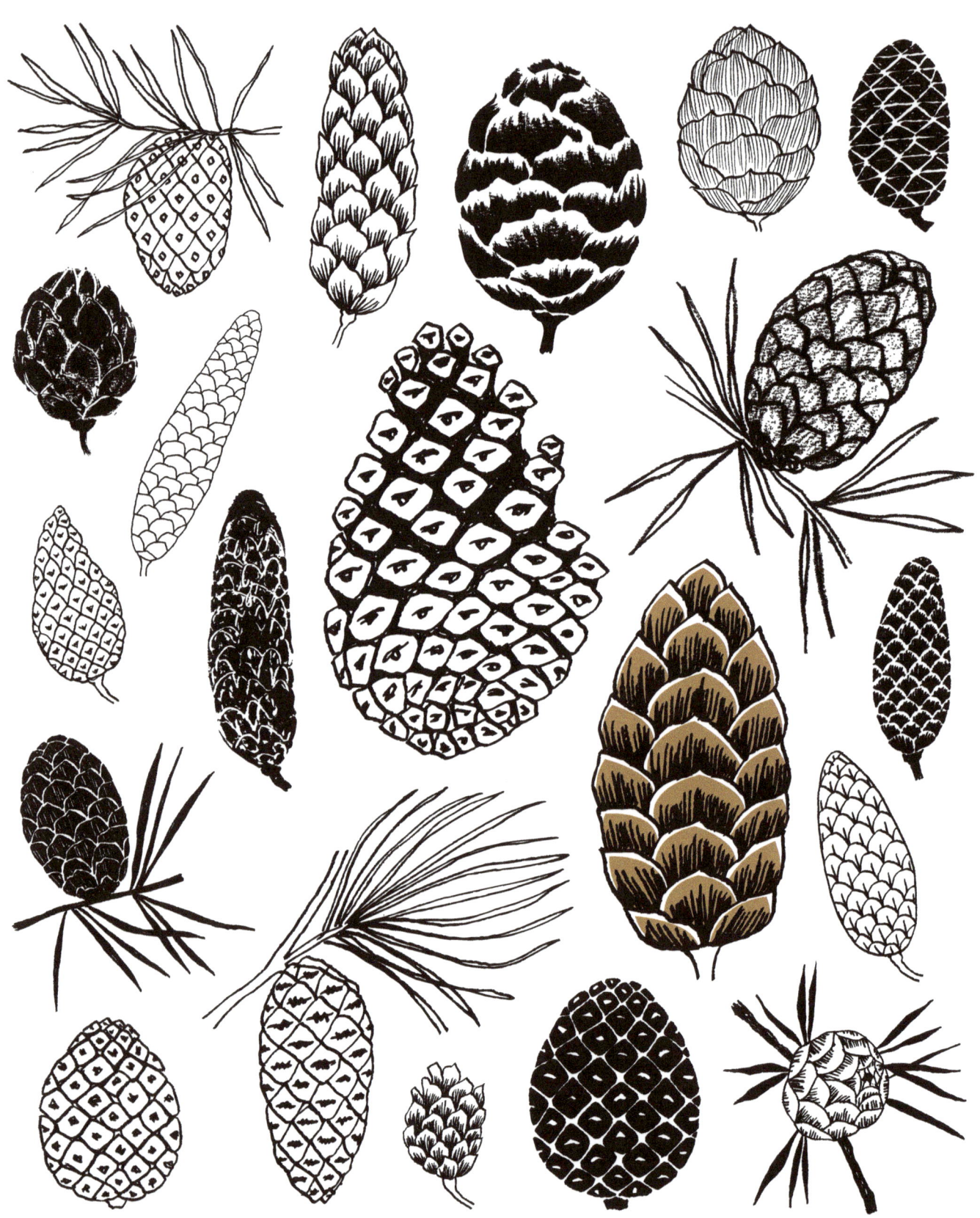

DRAW 20
PINECONES

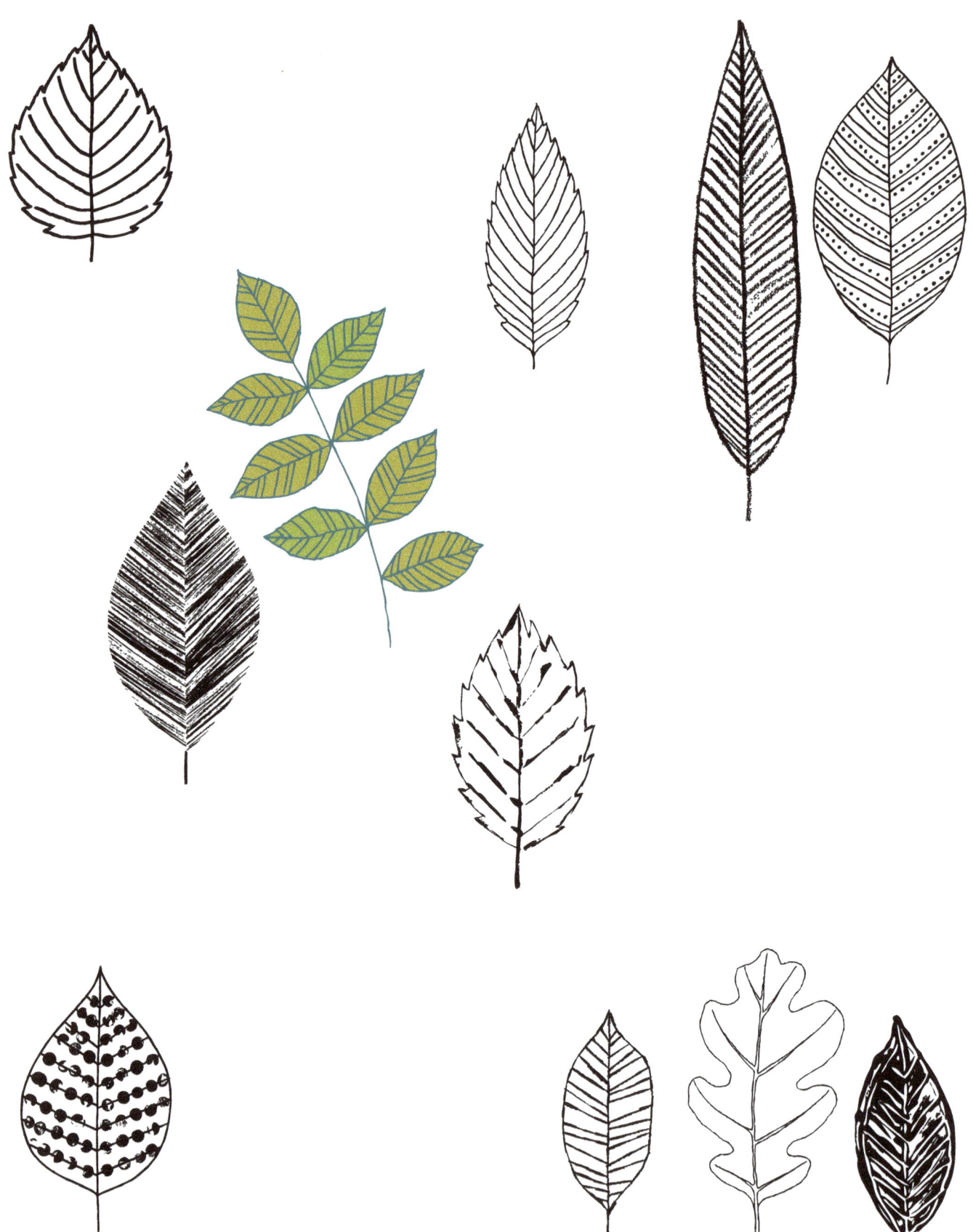

DRAW 20
LEAVES

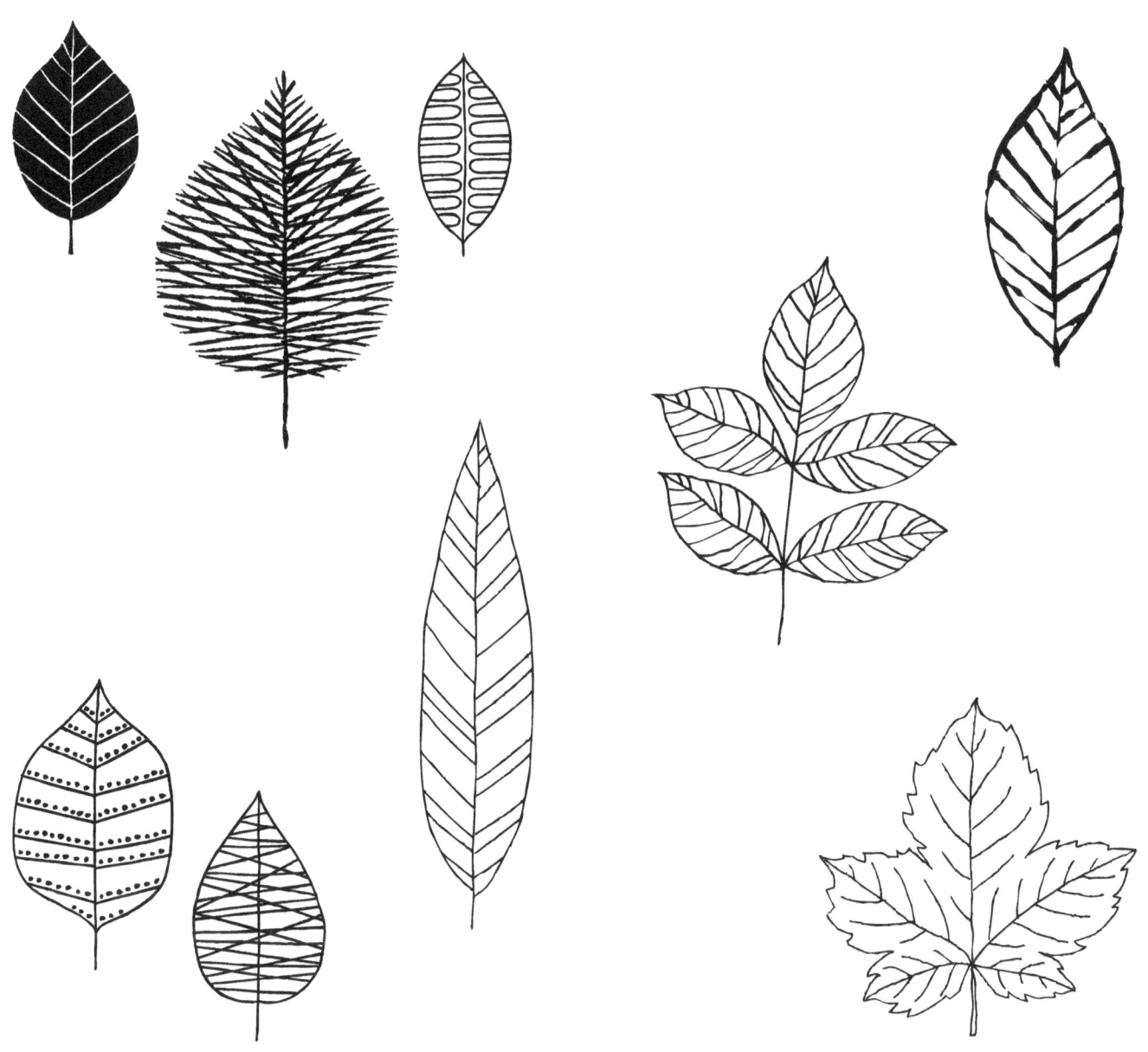

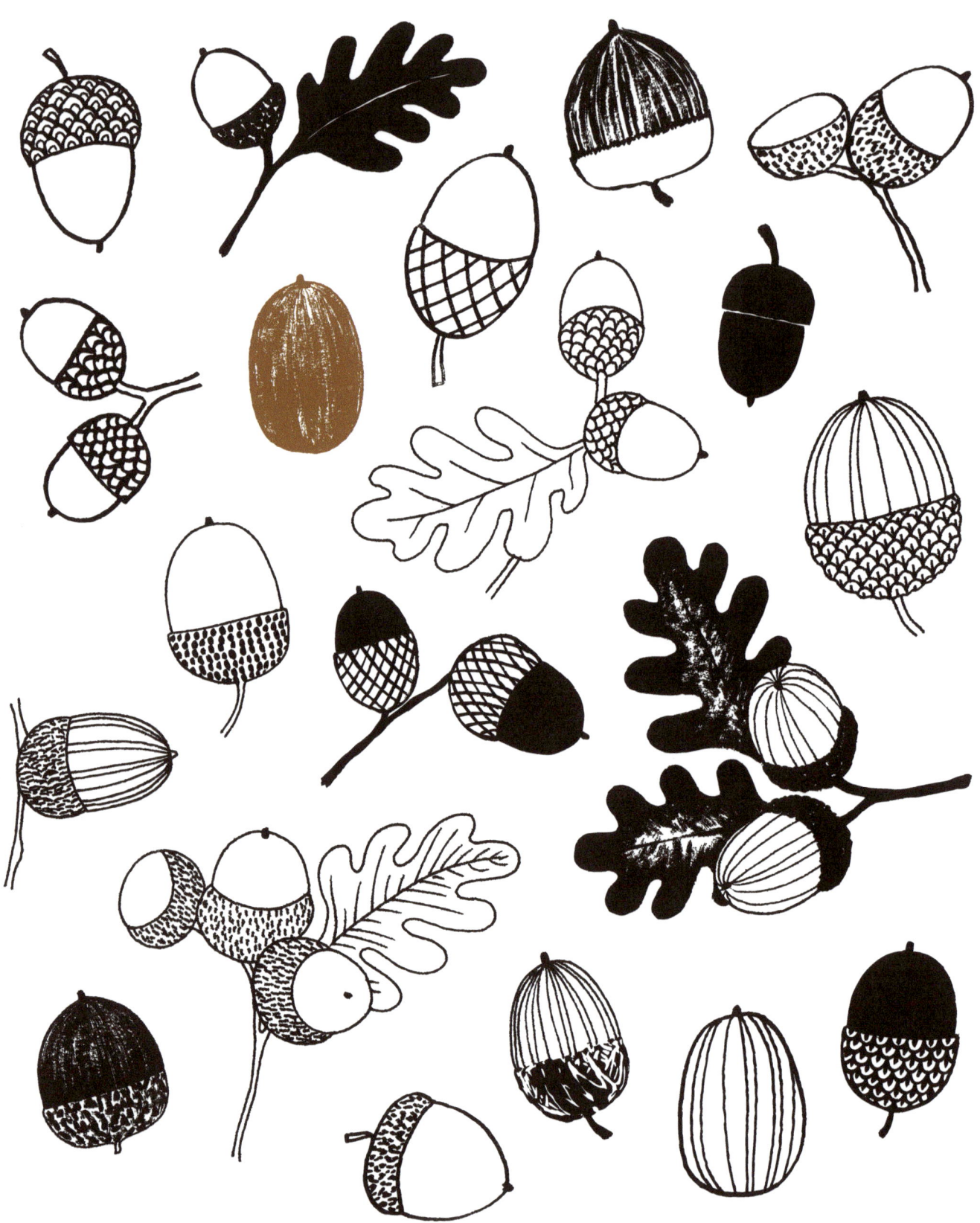

DRAW 20 acorns

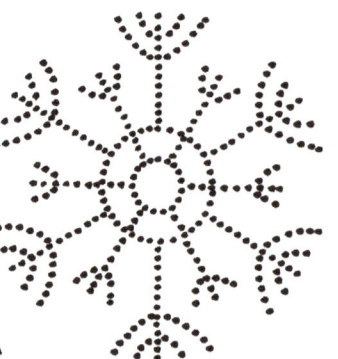
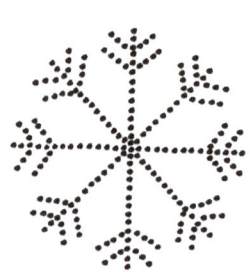
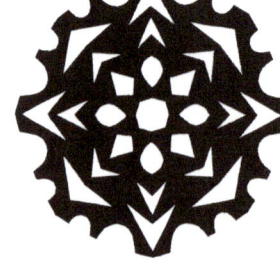
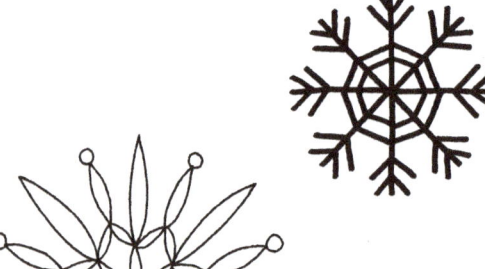

DRAW 20
SNOWFLAKES

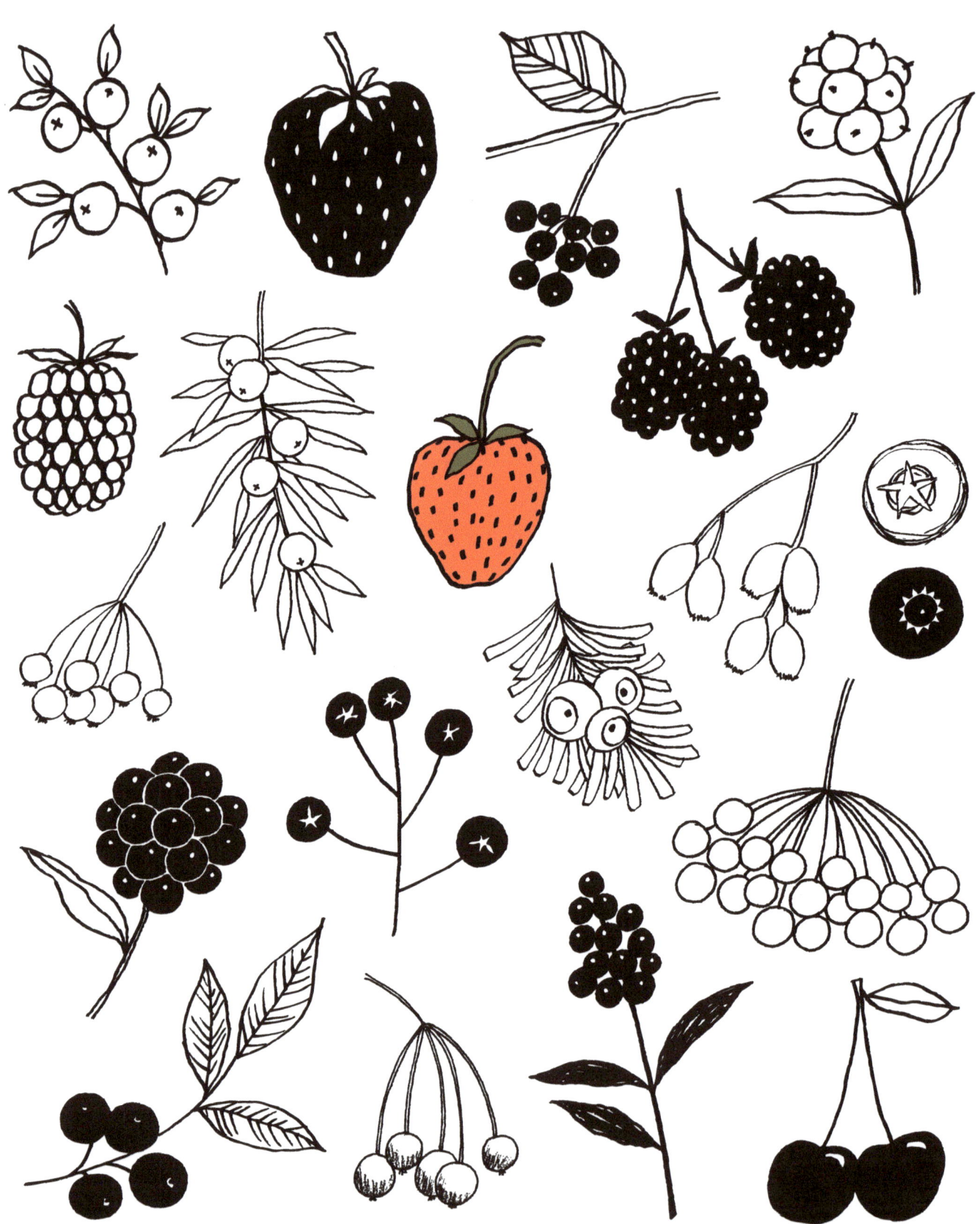

DRAW 20
berries

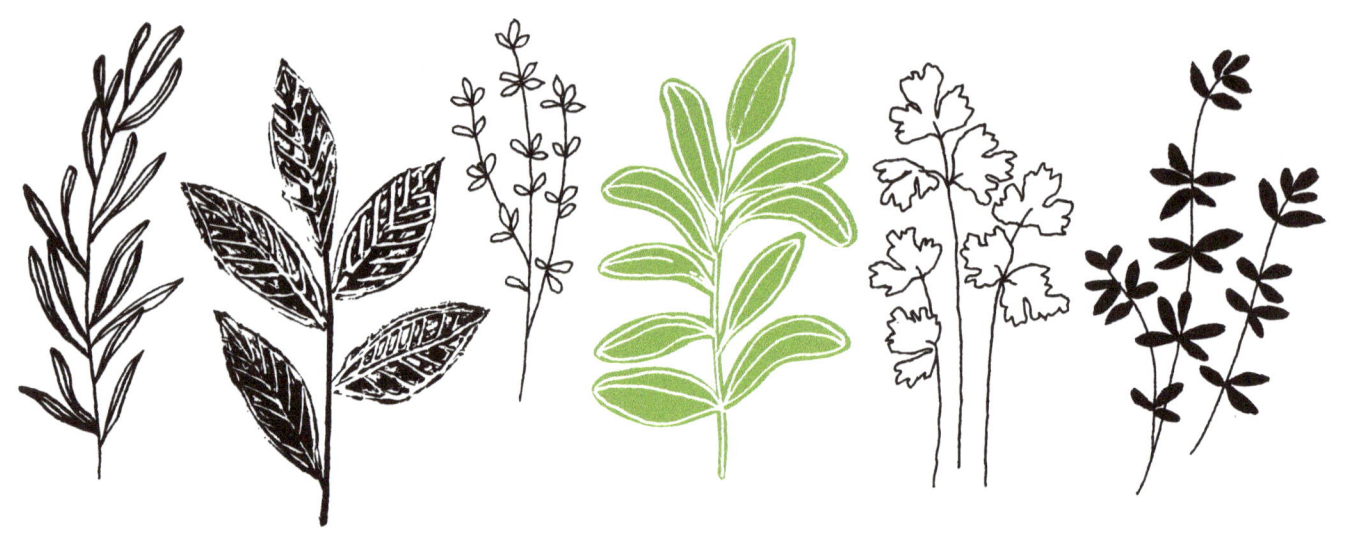
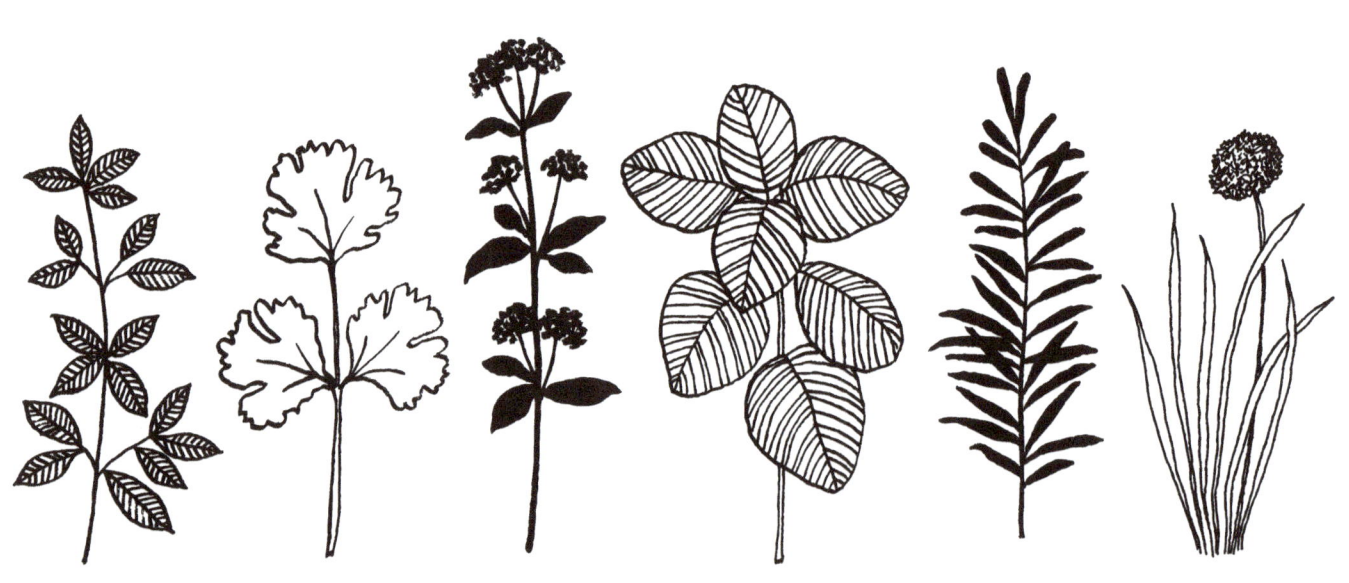

DRAW 20
Herbs

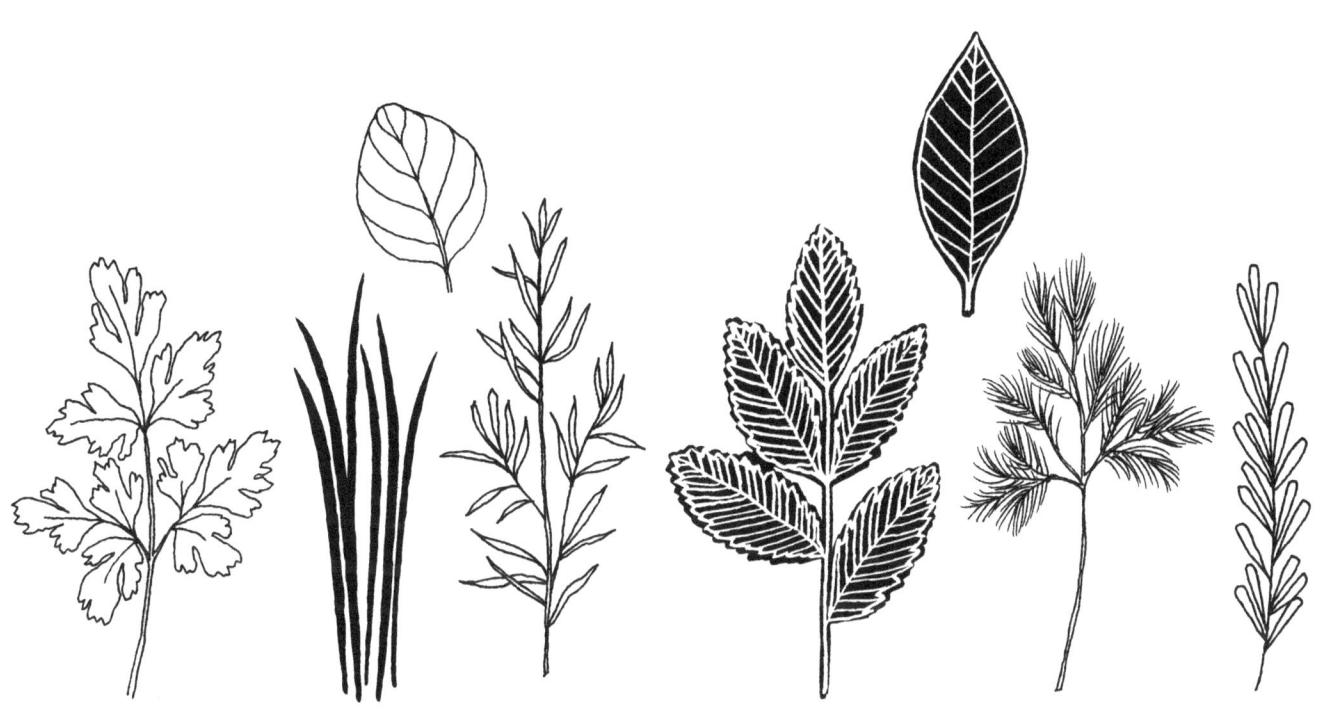

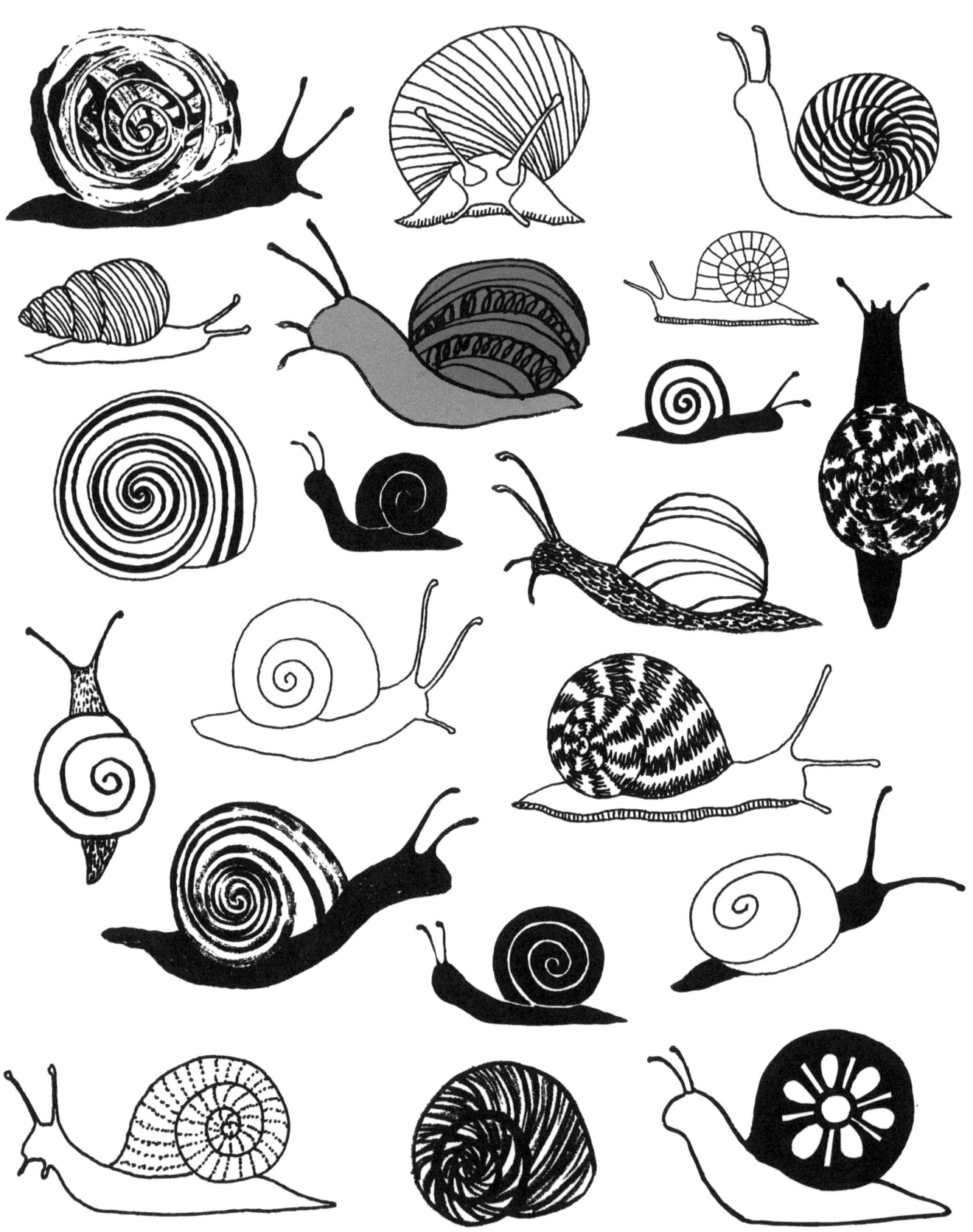

DRAW 20
snails

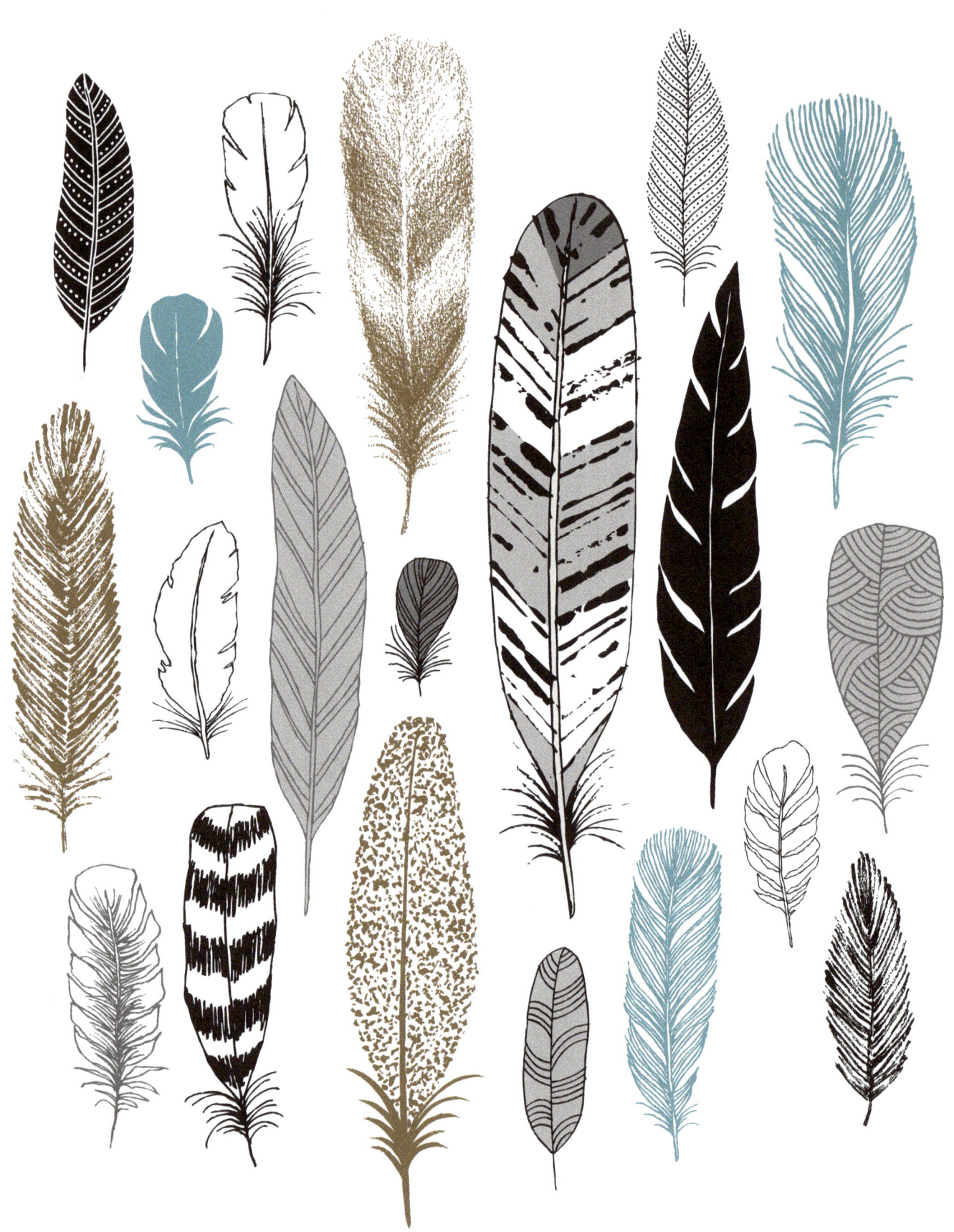

DRAW 20 FEATHERS

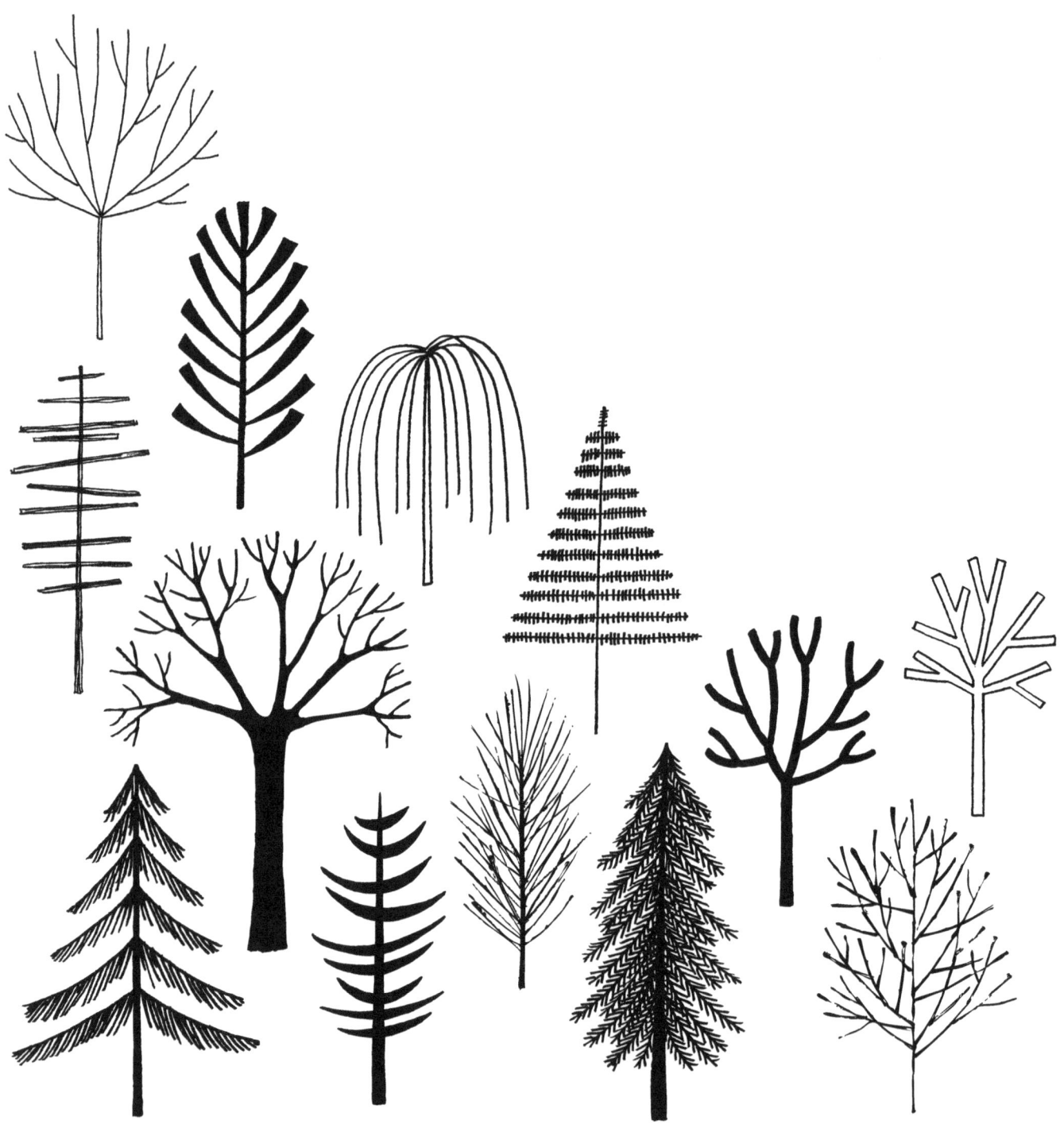

DRAW 20
Winter Trees

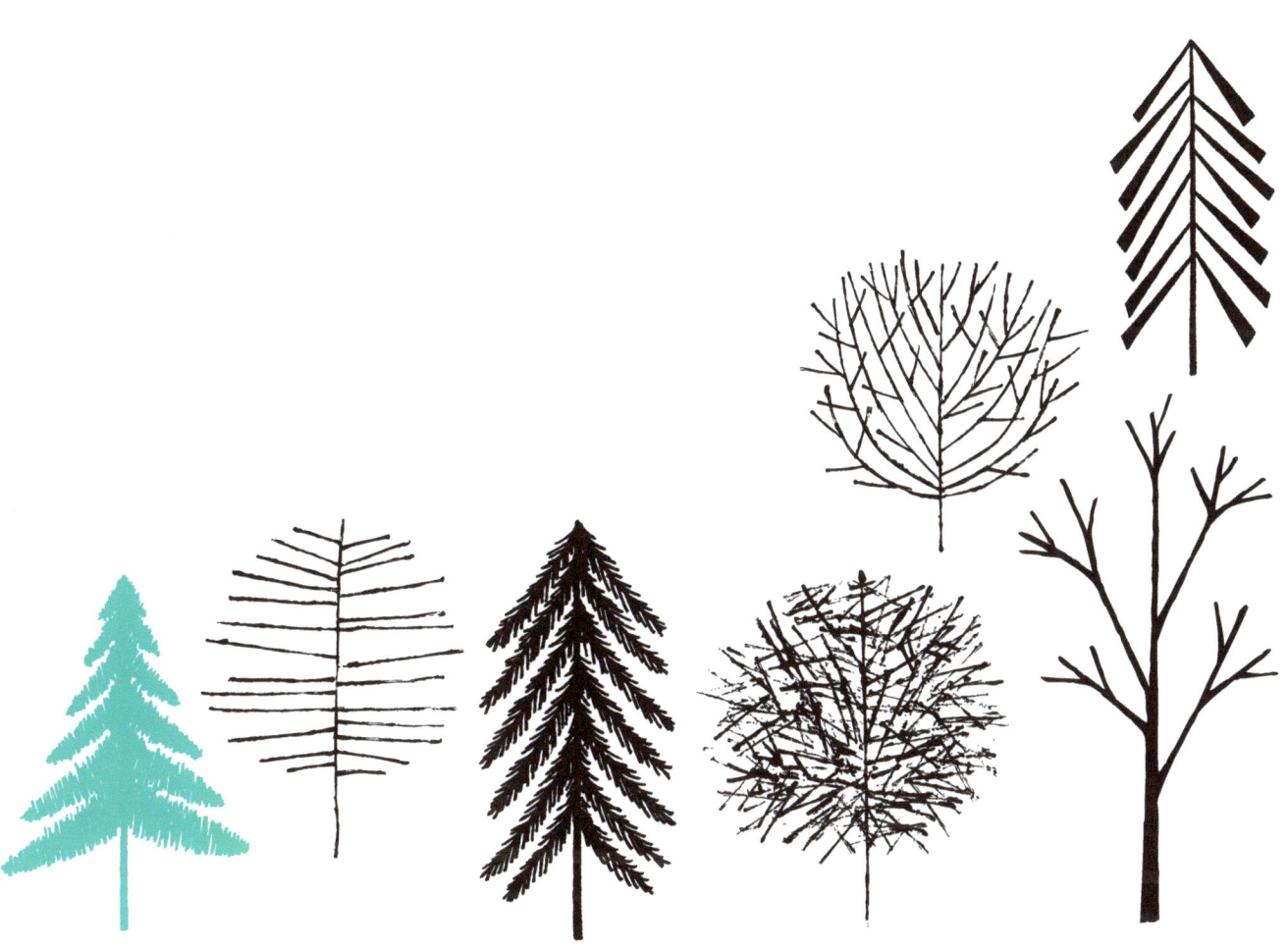

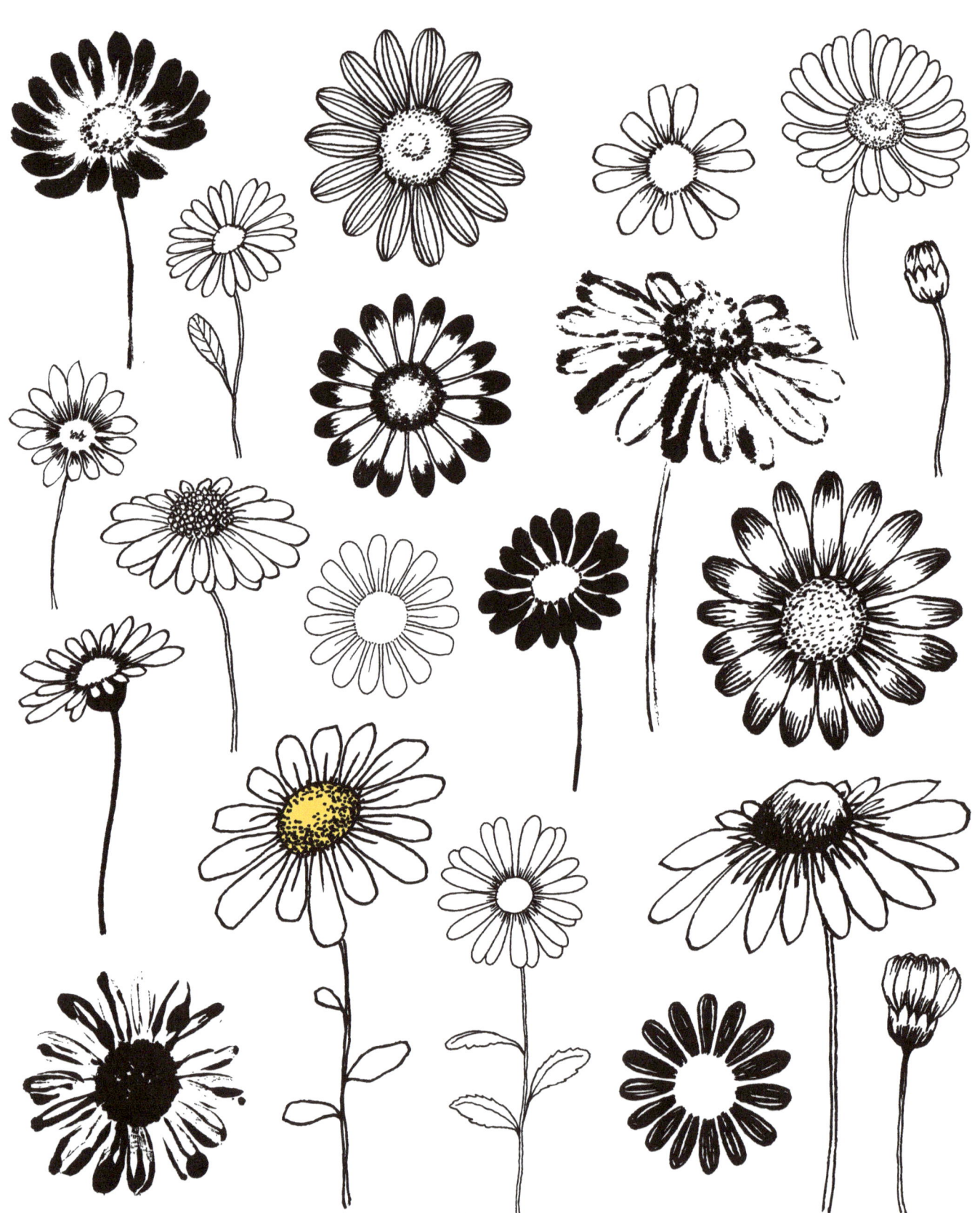

DRAW 20
daisies

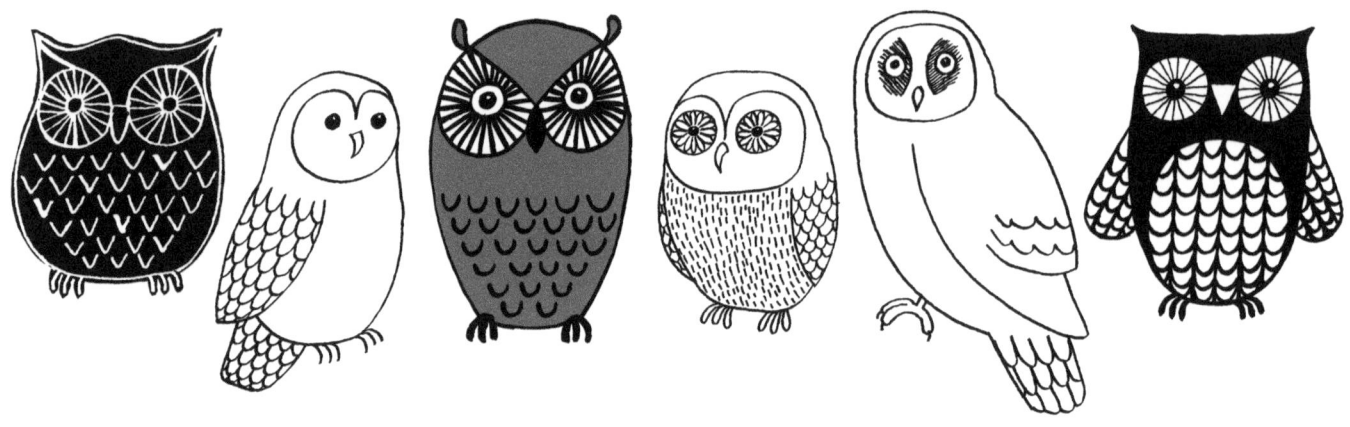
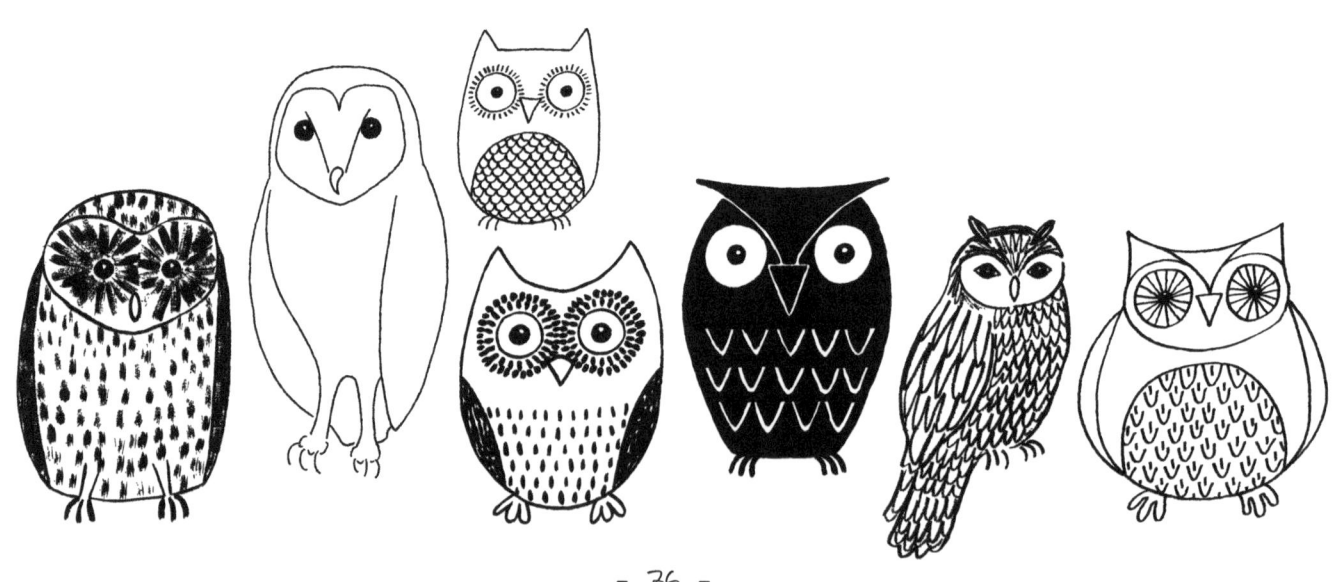

DRAW 20
Owls

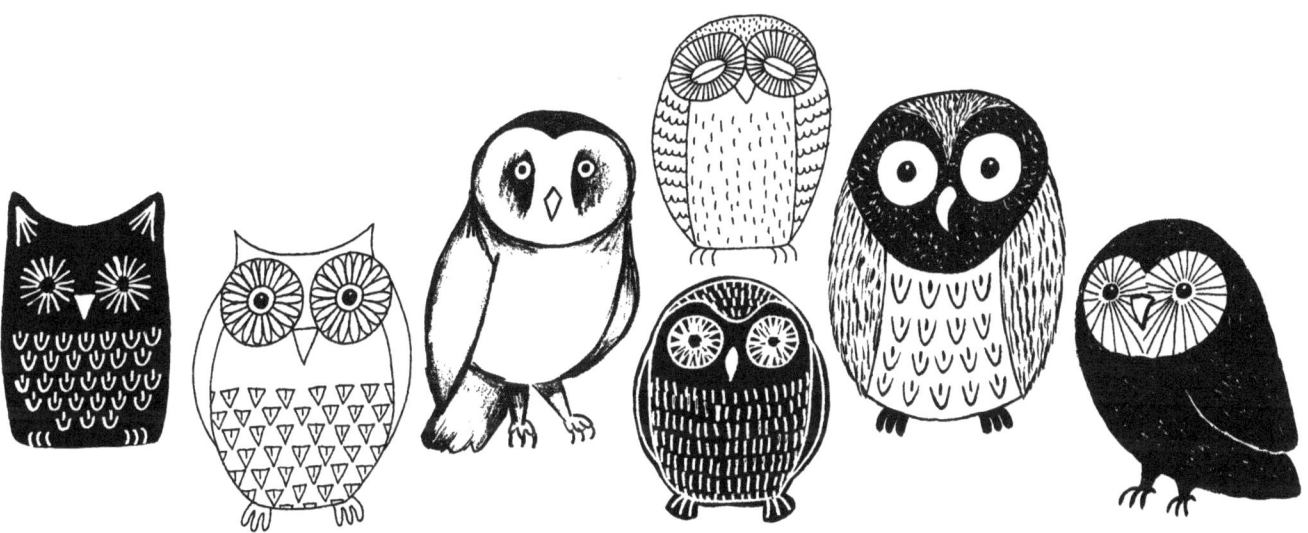

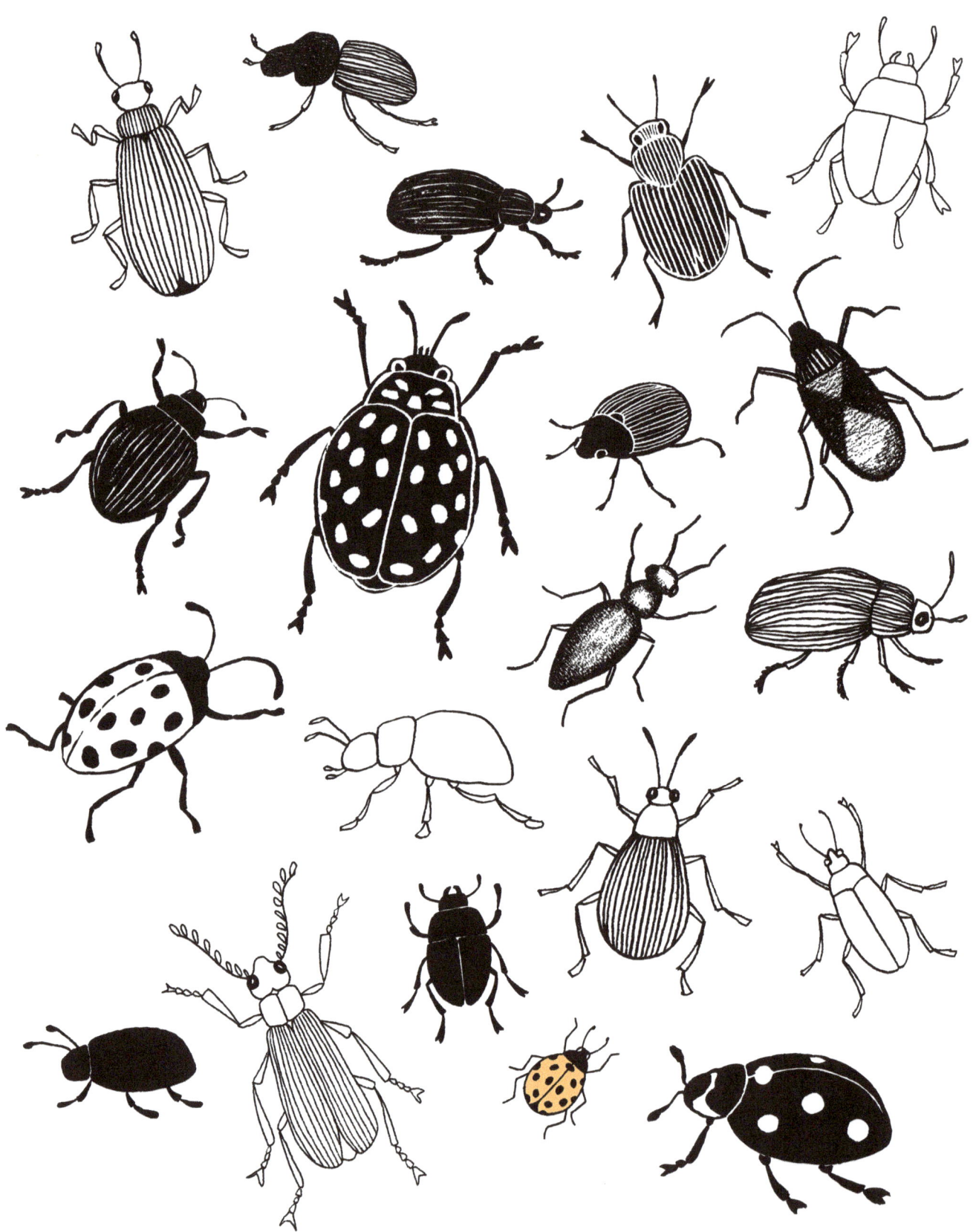

DRAW 20
Beetles

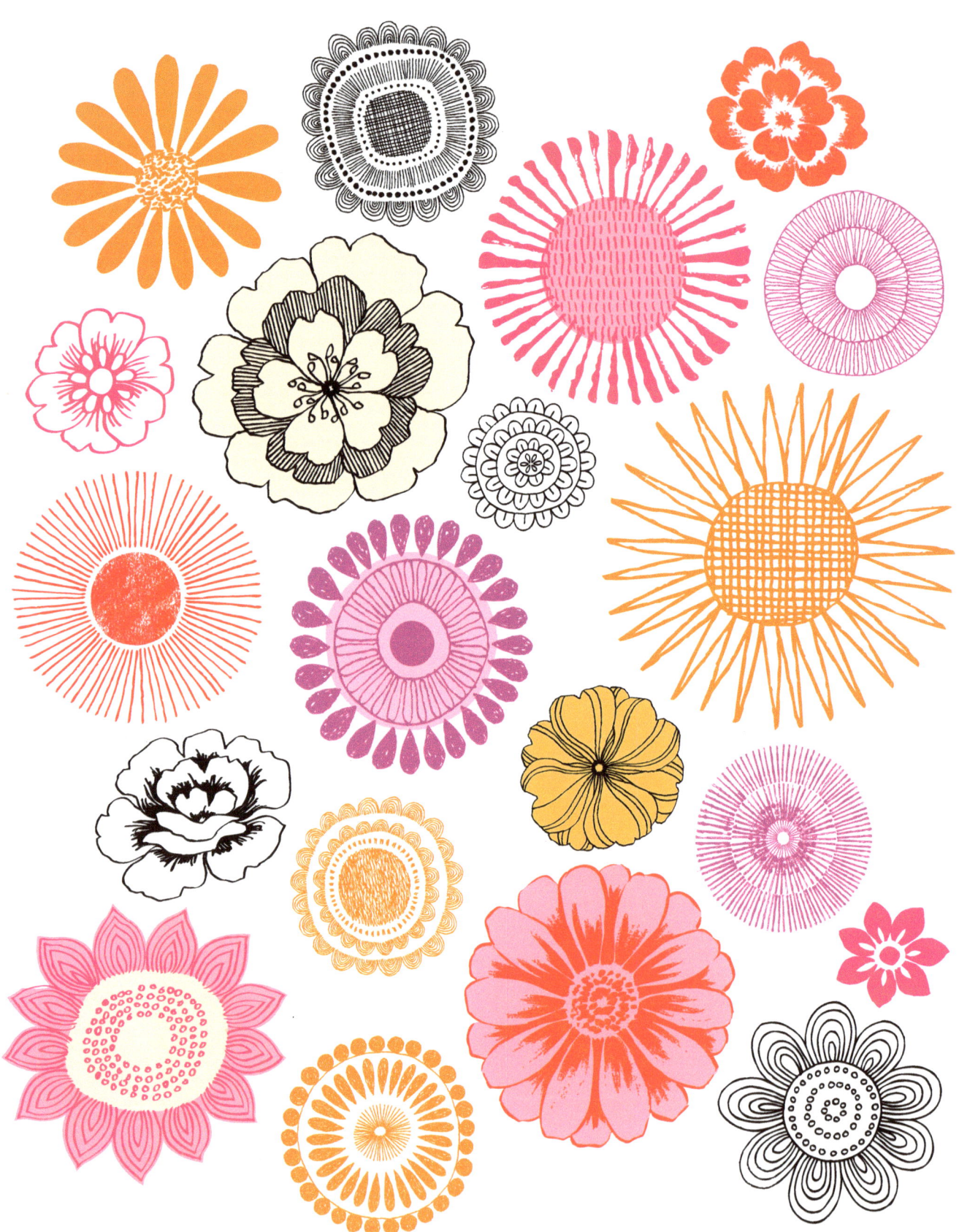

DRAW 20 flowers

DRAW 20 CLOUDS

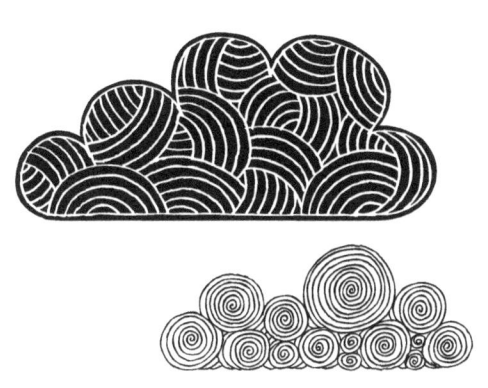
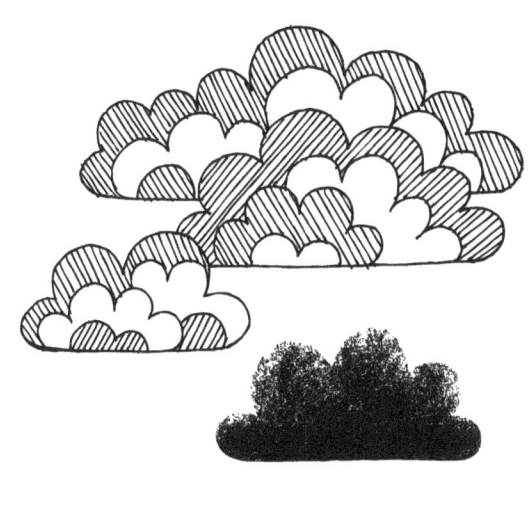
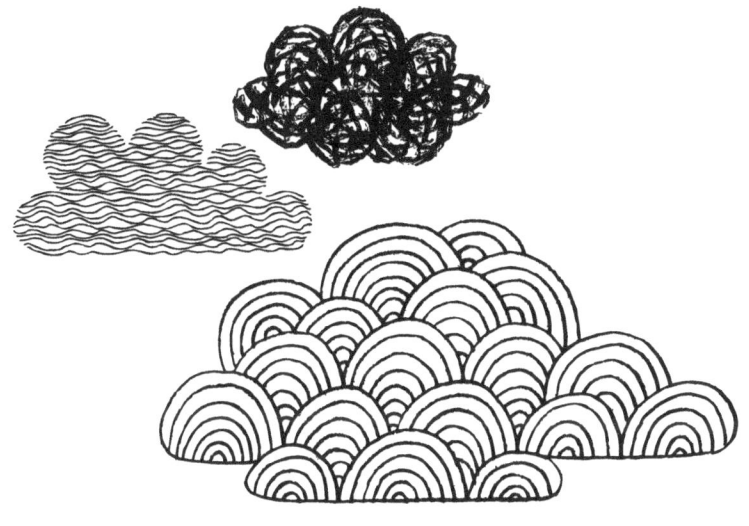
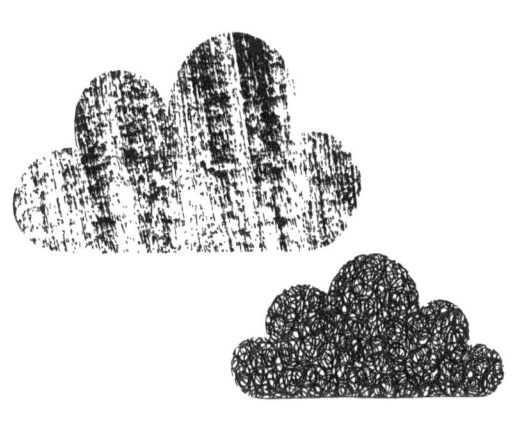

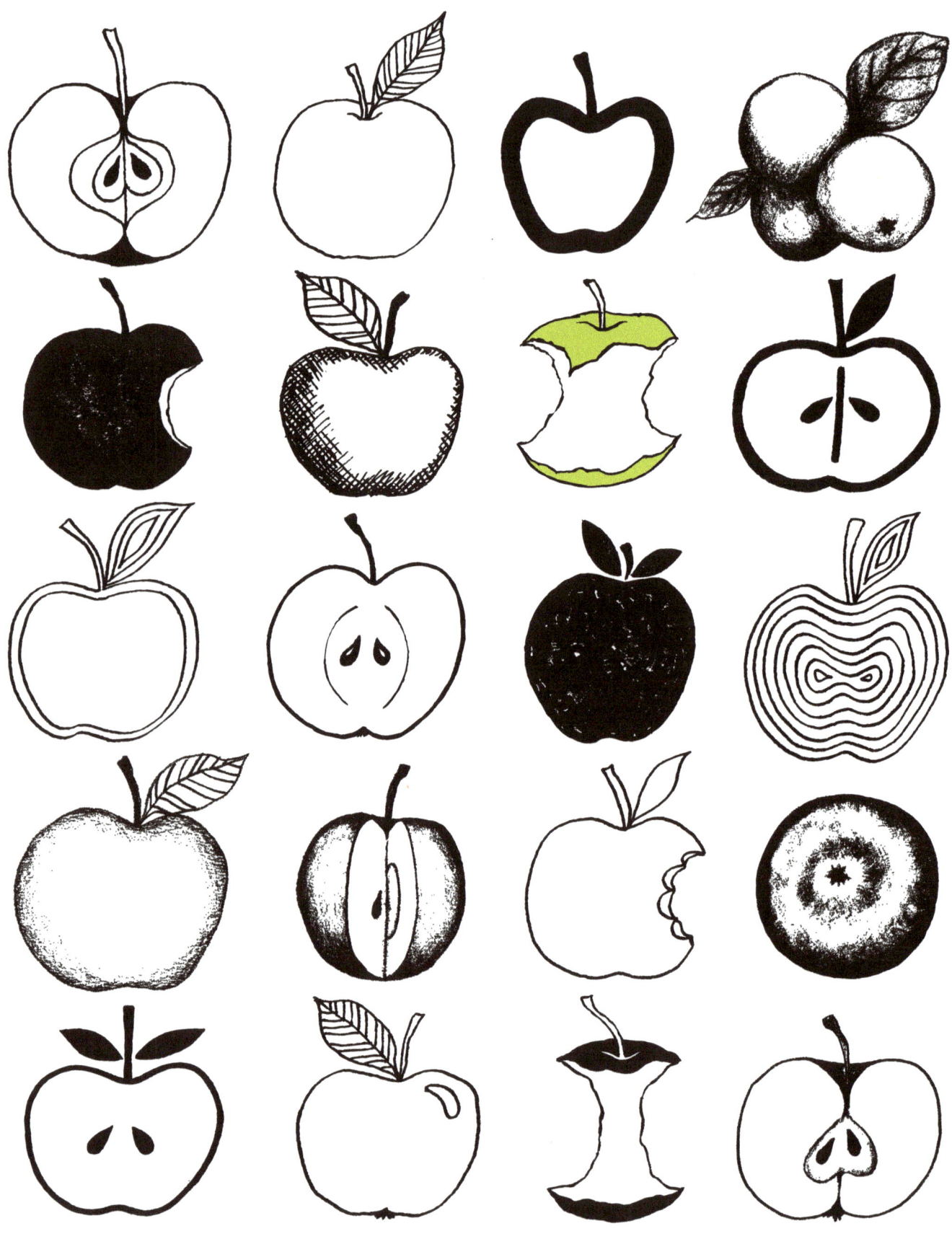

DRAW 20
apples

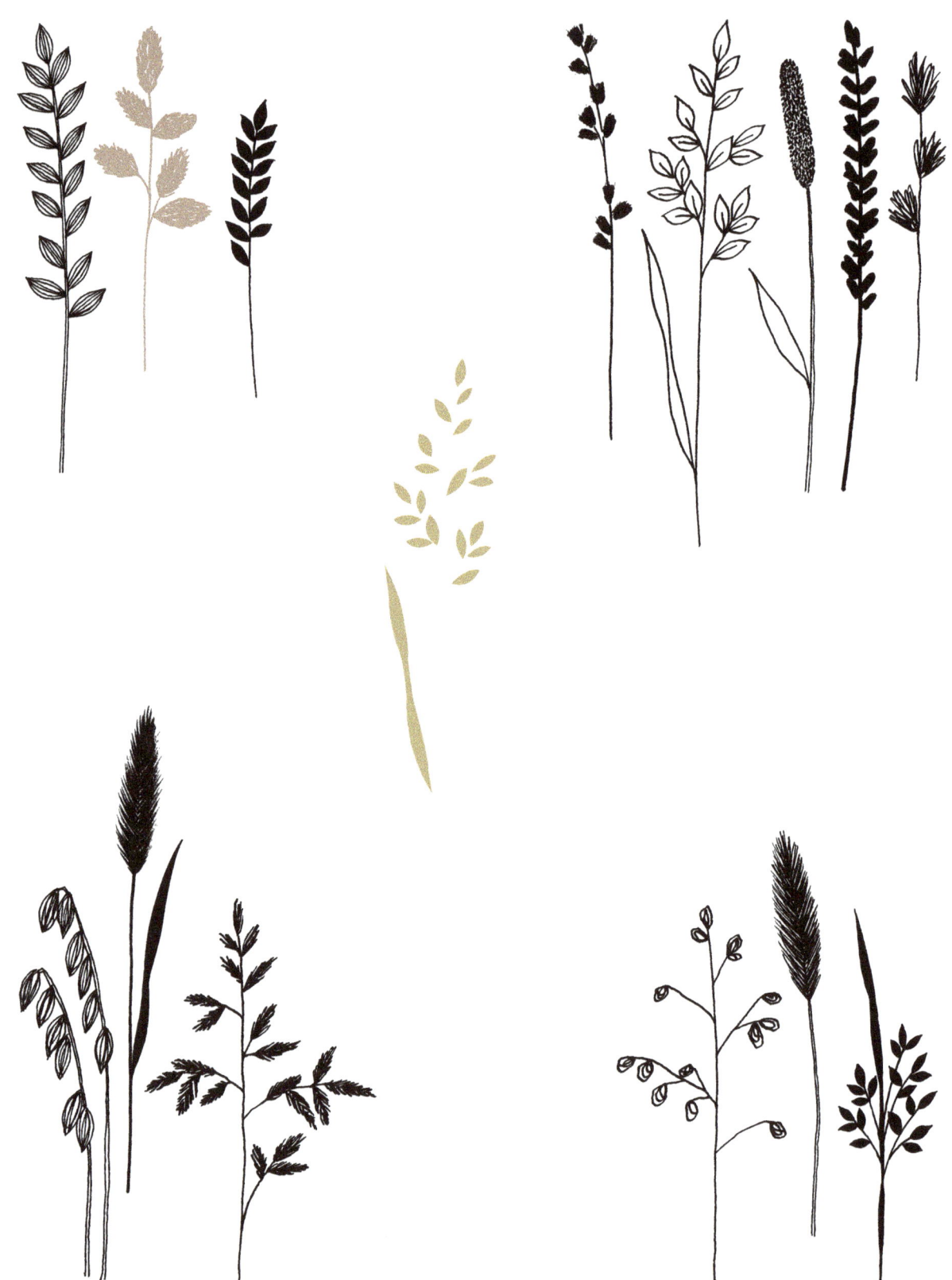

DRAW 20
GRASSES

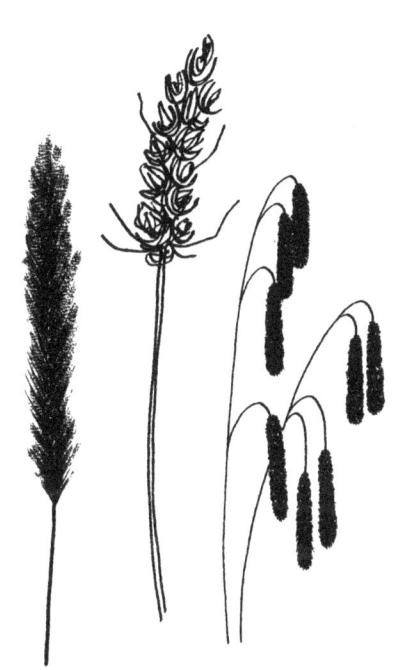
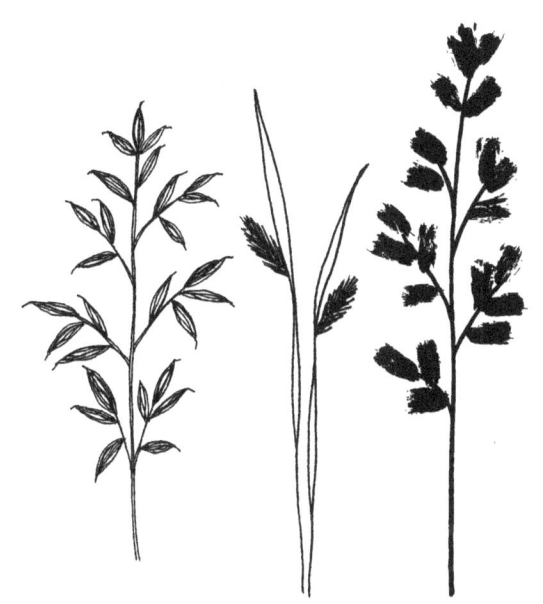

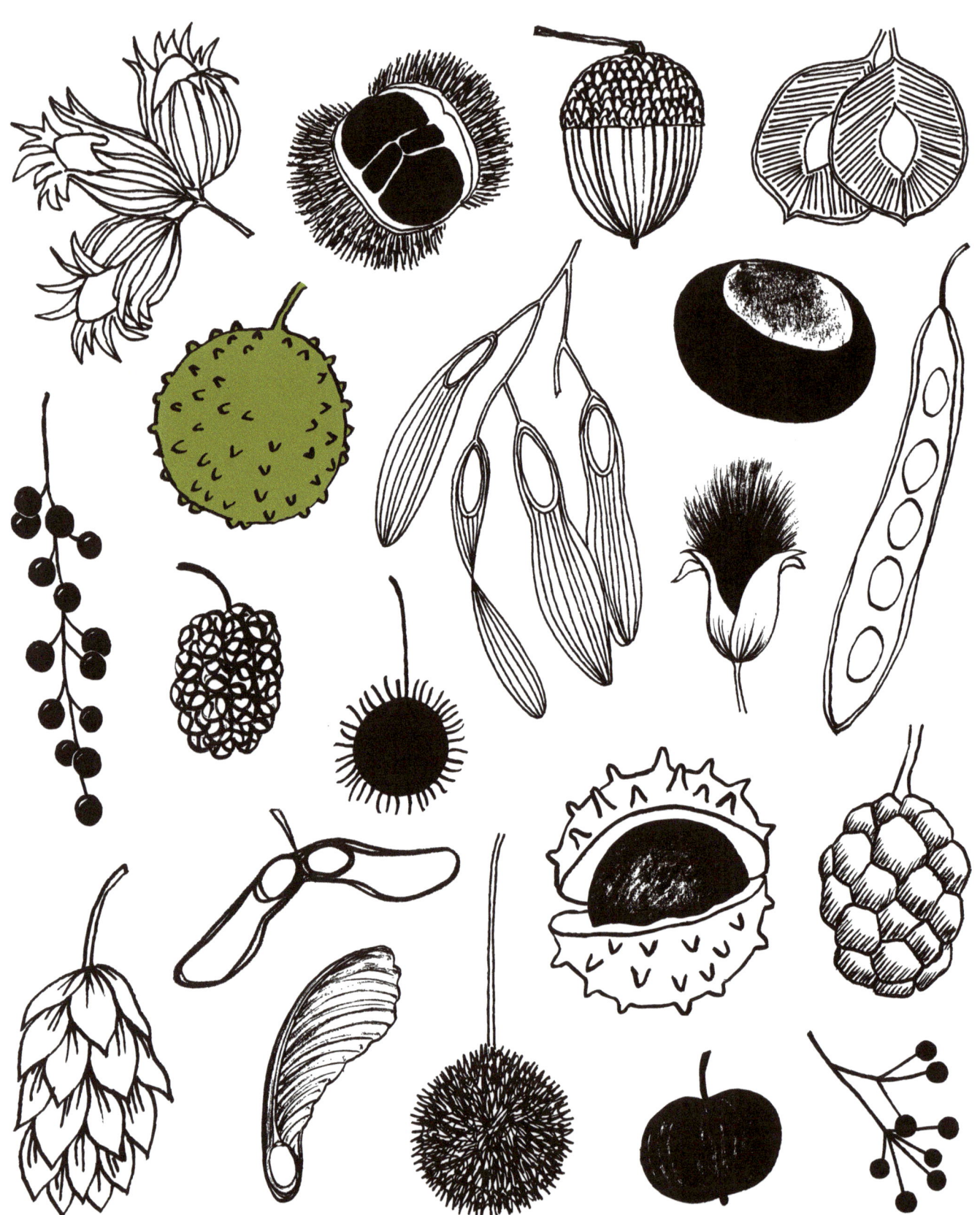

DRAW 20
tree seeds

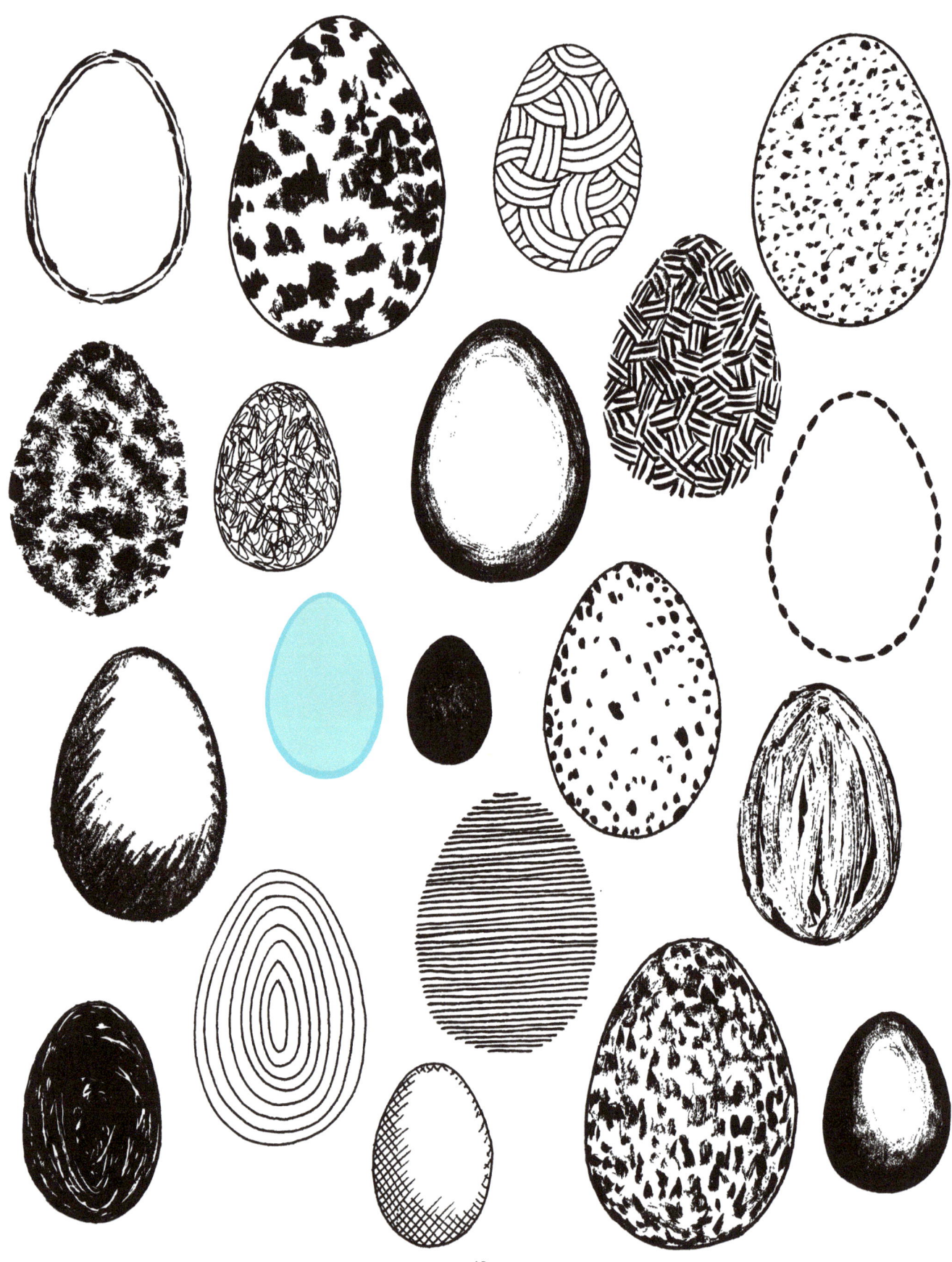

DRAW 20
eggs

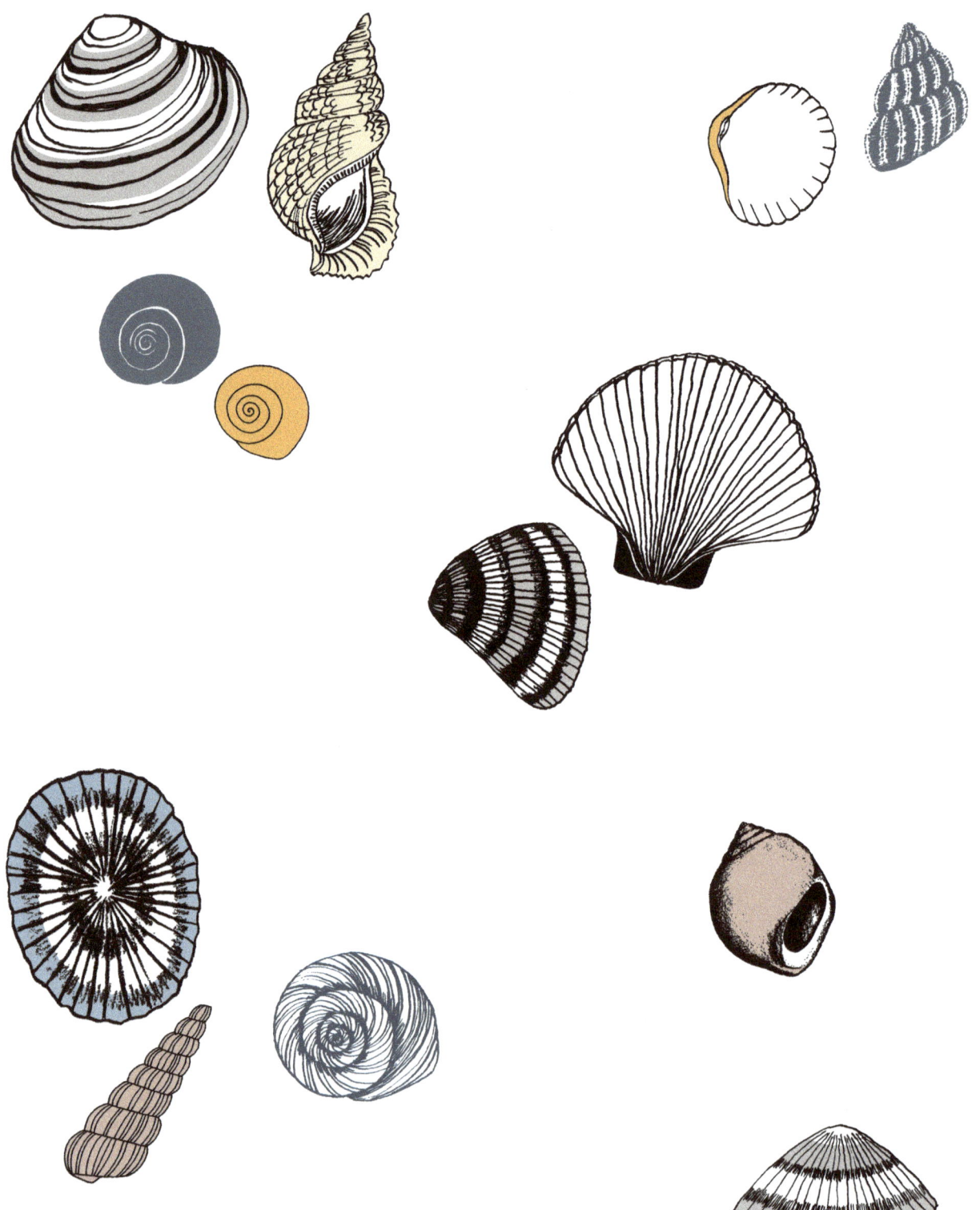

DRAW 20 *shells*

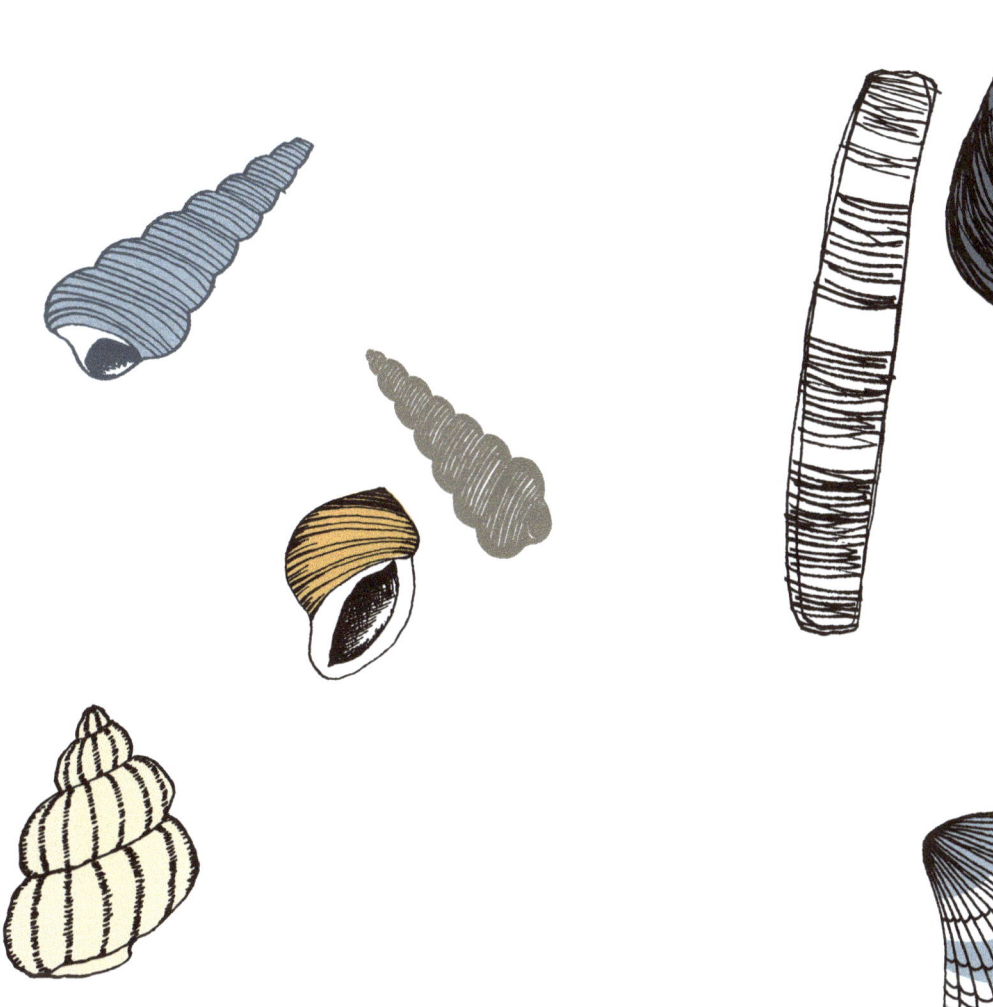

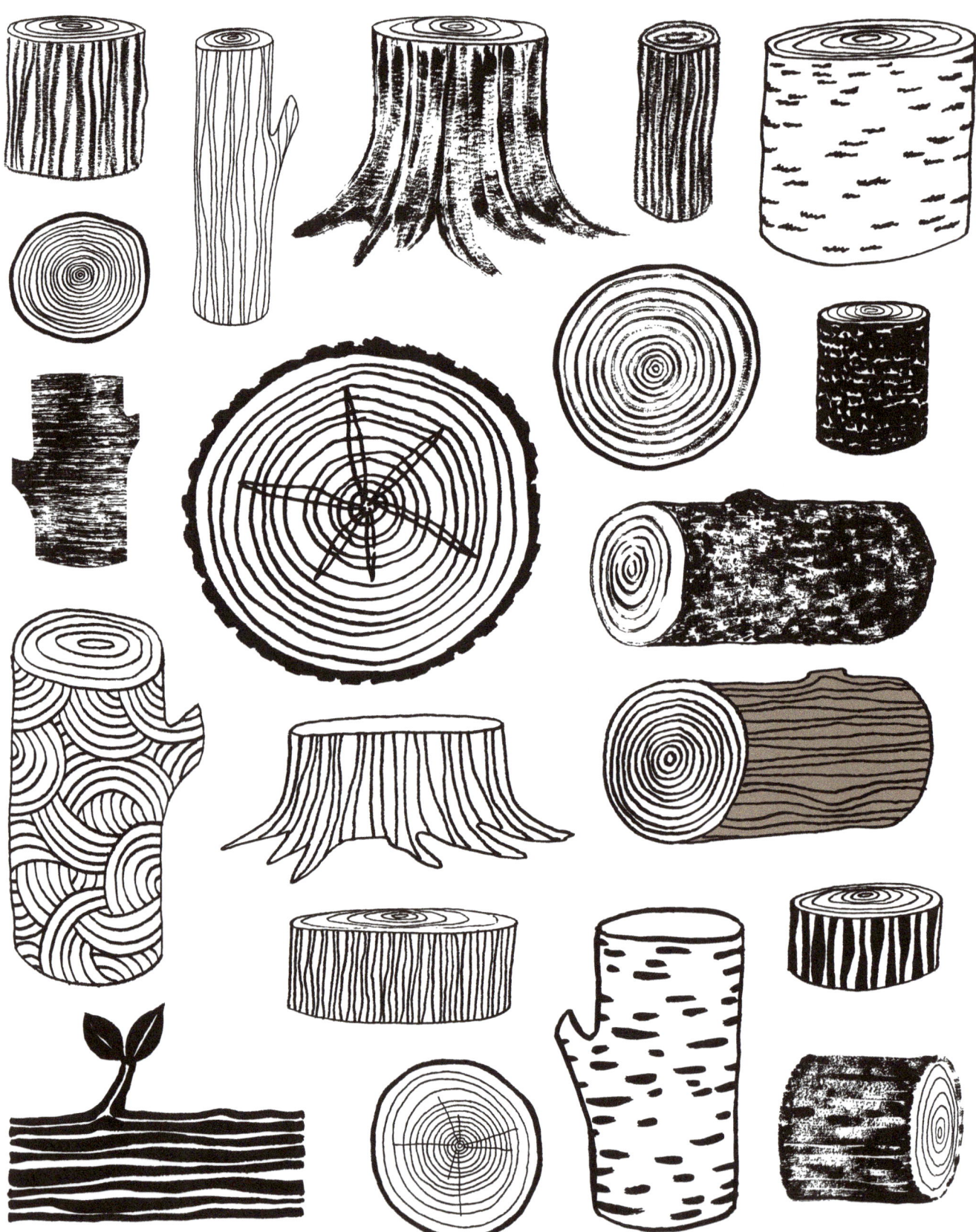

DRAW 20
logs

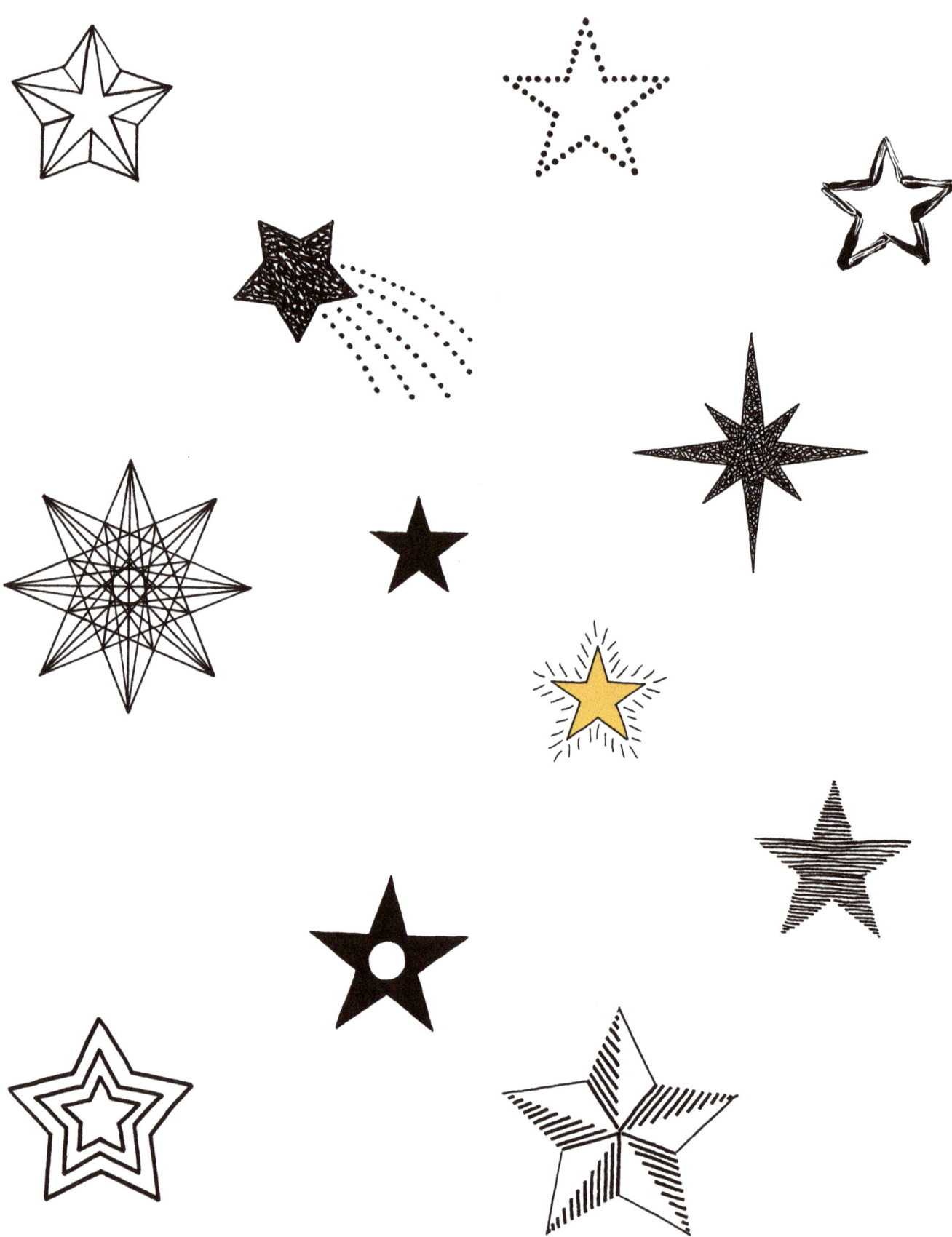

DRAW 20
STARS

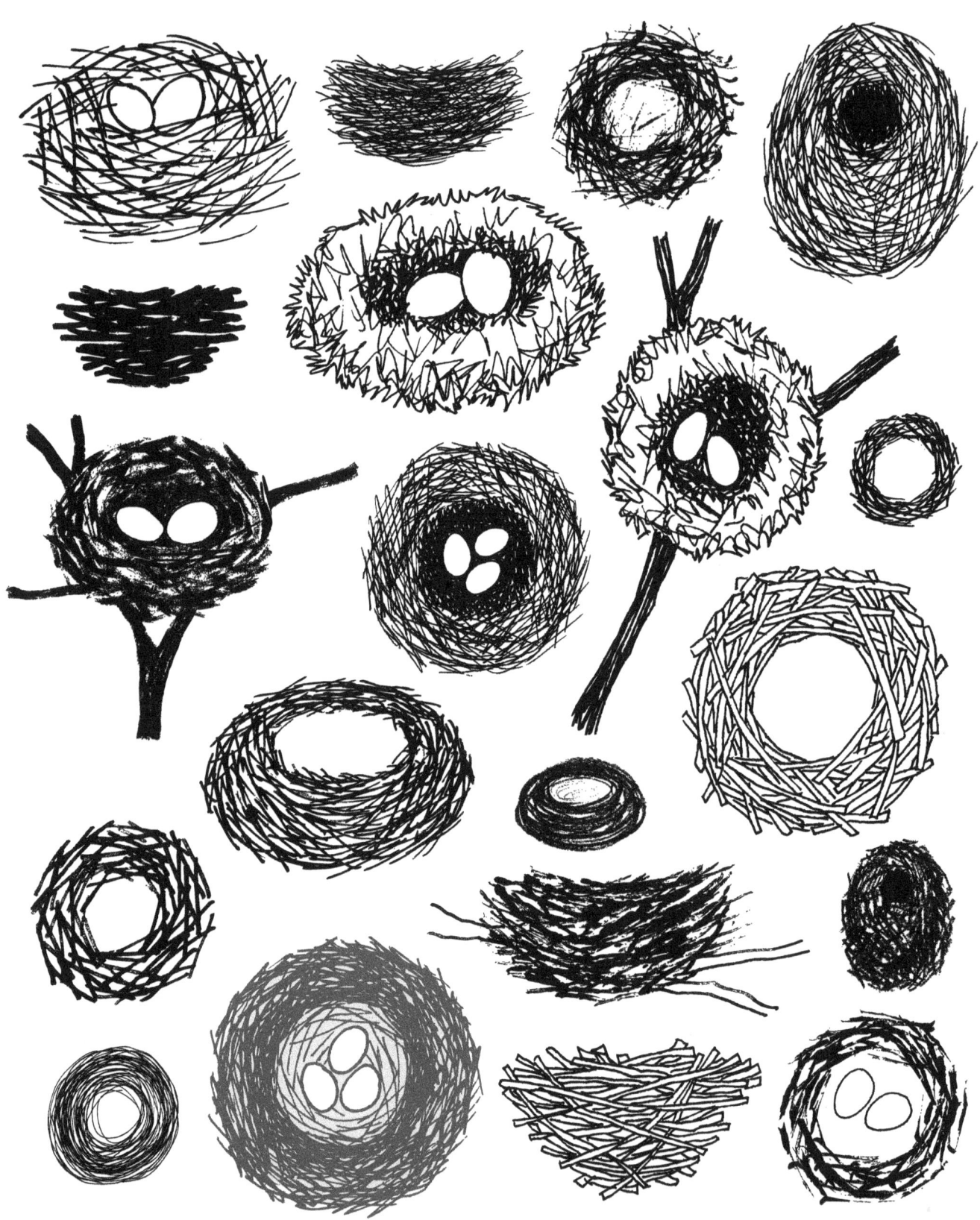

DRAW 20
nests

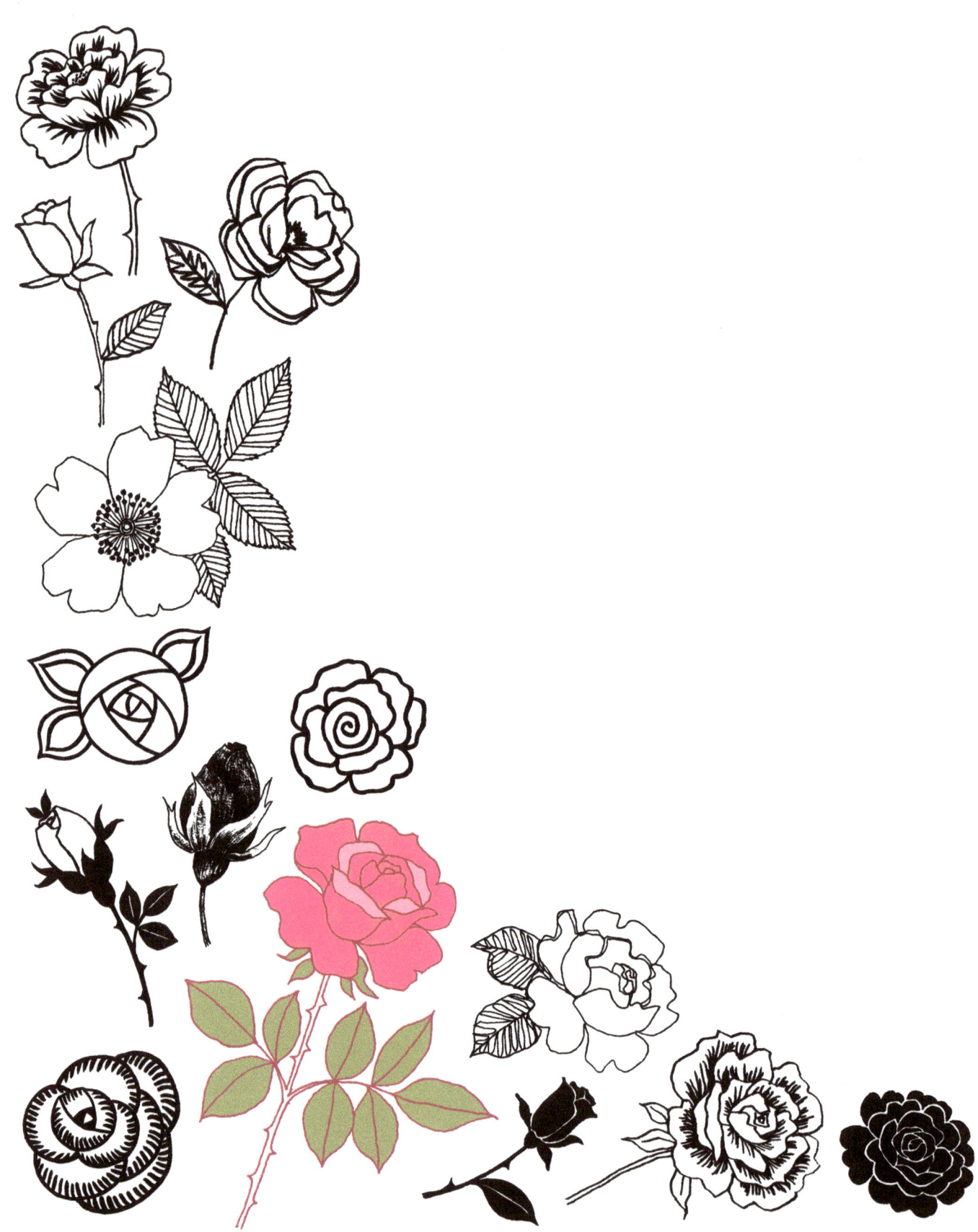

DRAW 20
roses

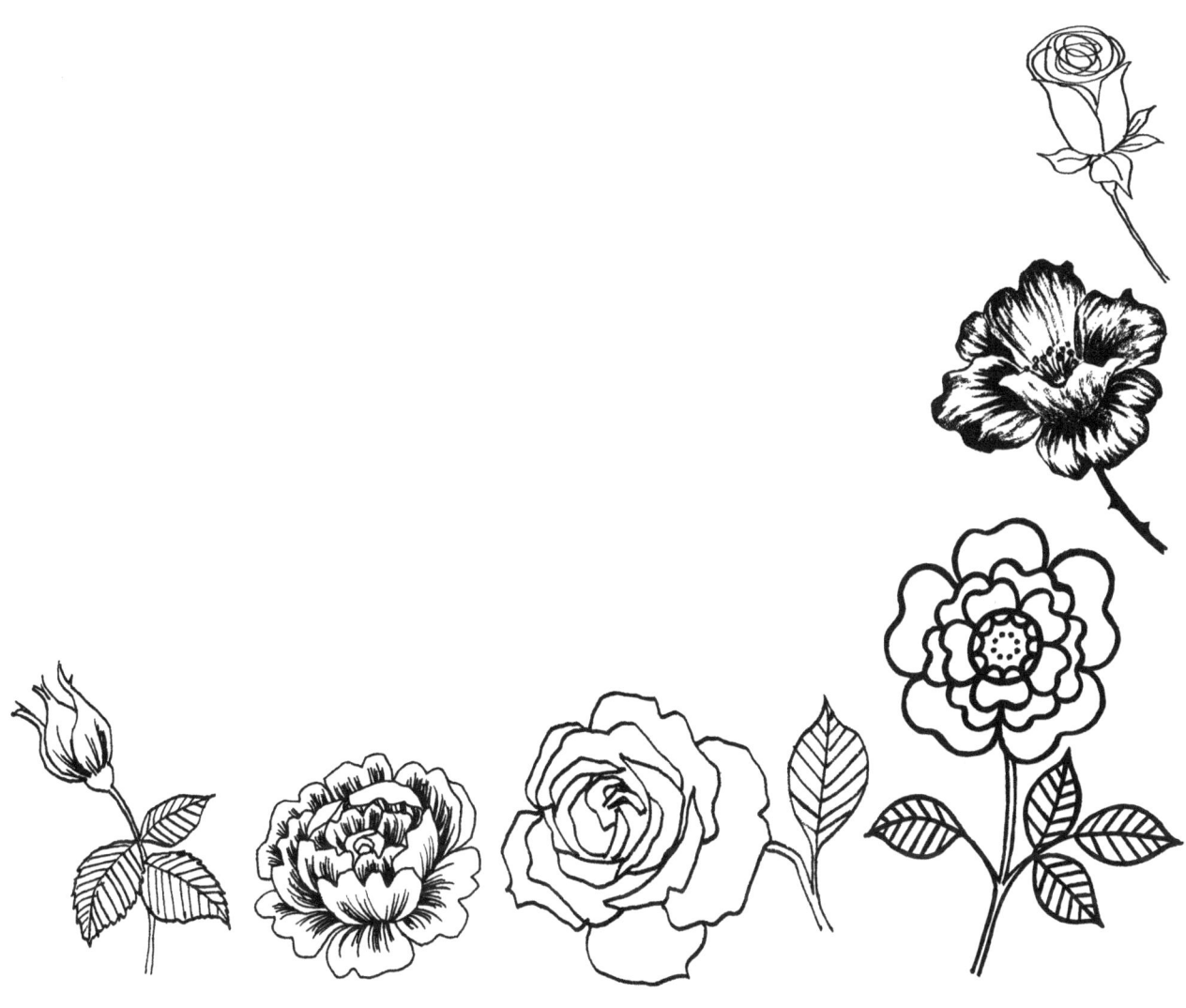

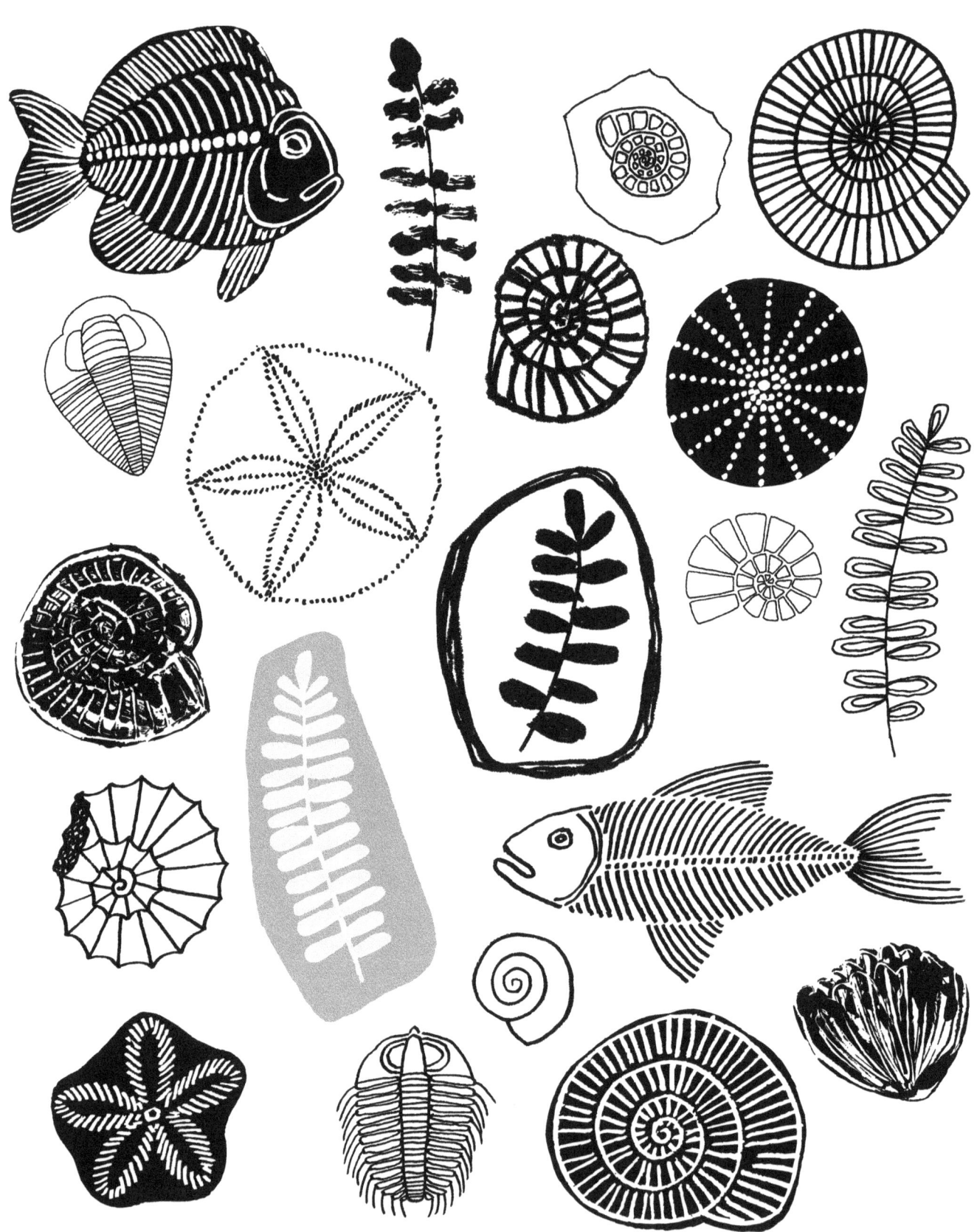

DRAW 20
FOSSILS

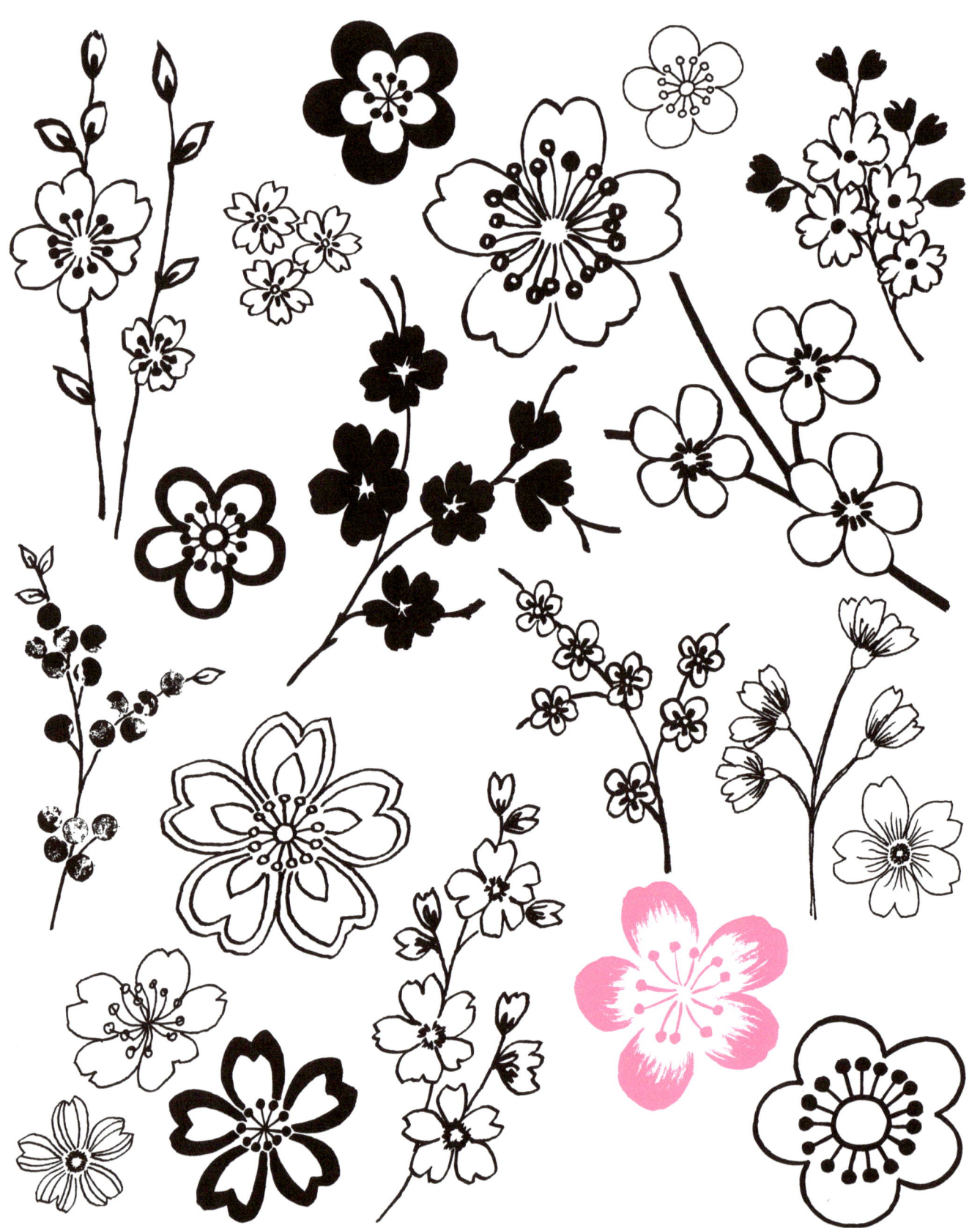

DRAW 20 *blossoms*

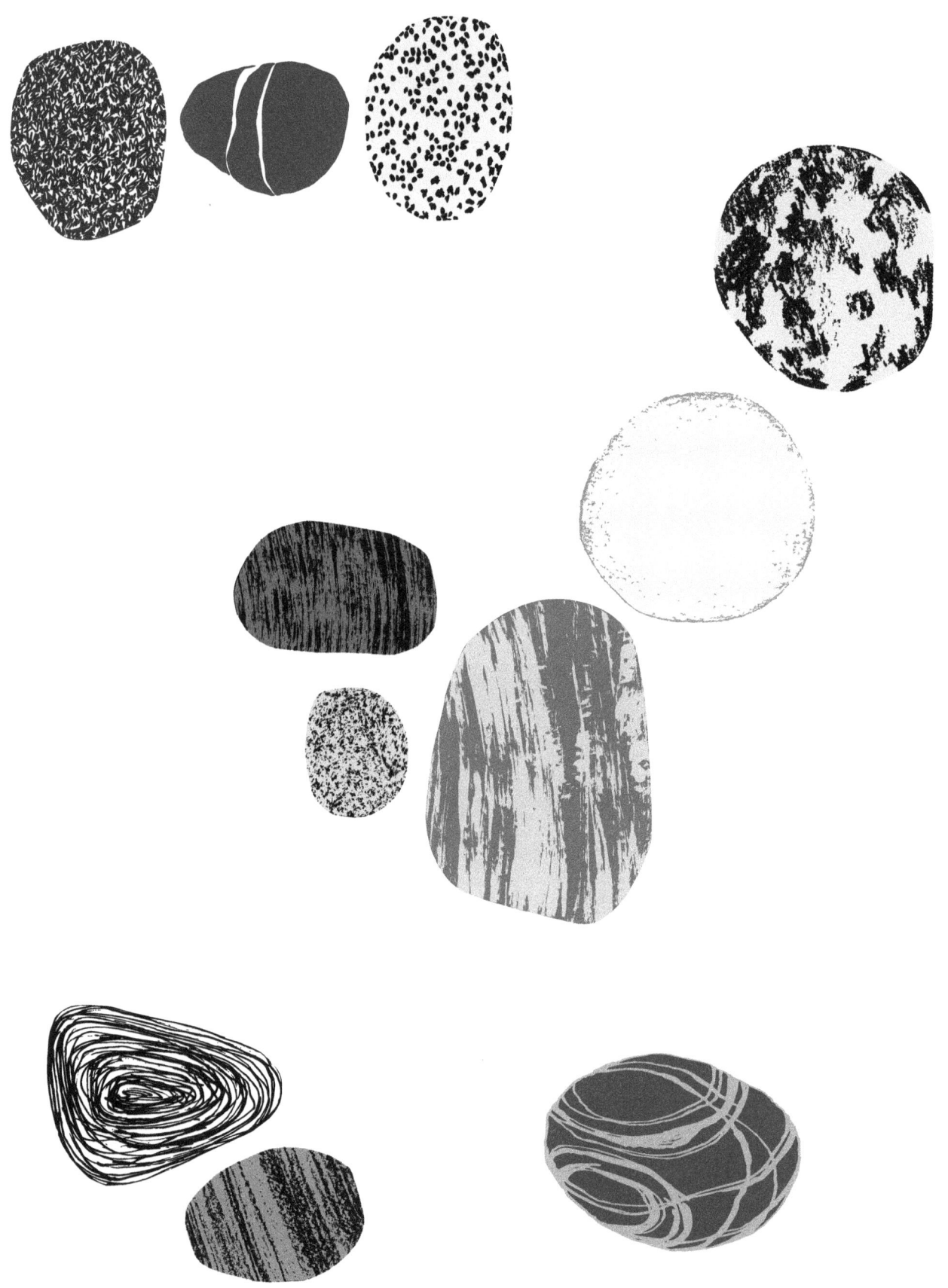

DRAW 20
STONES

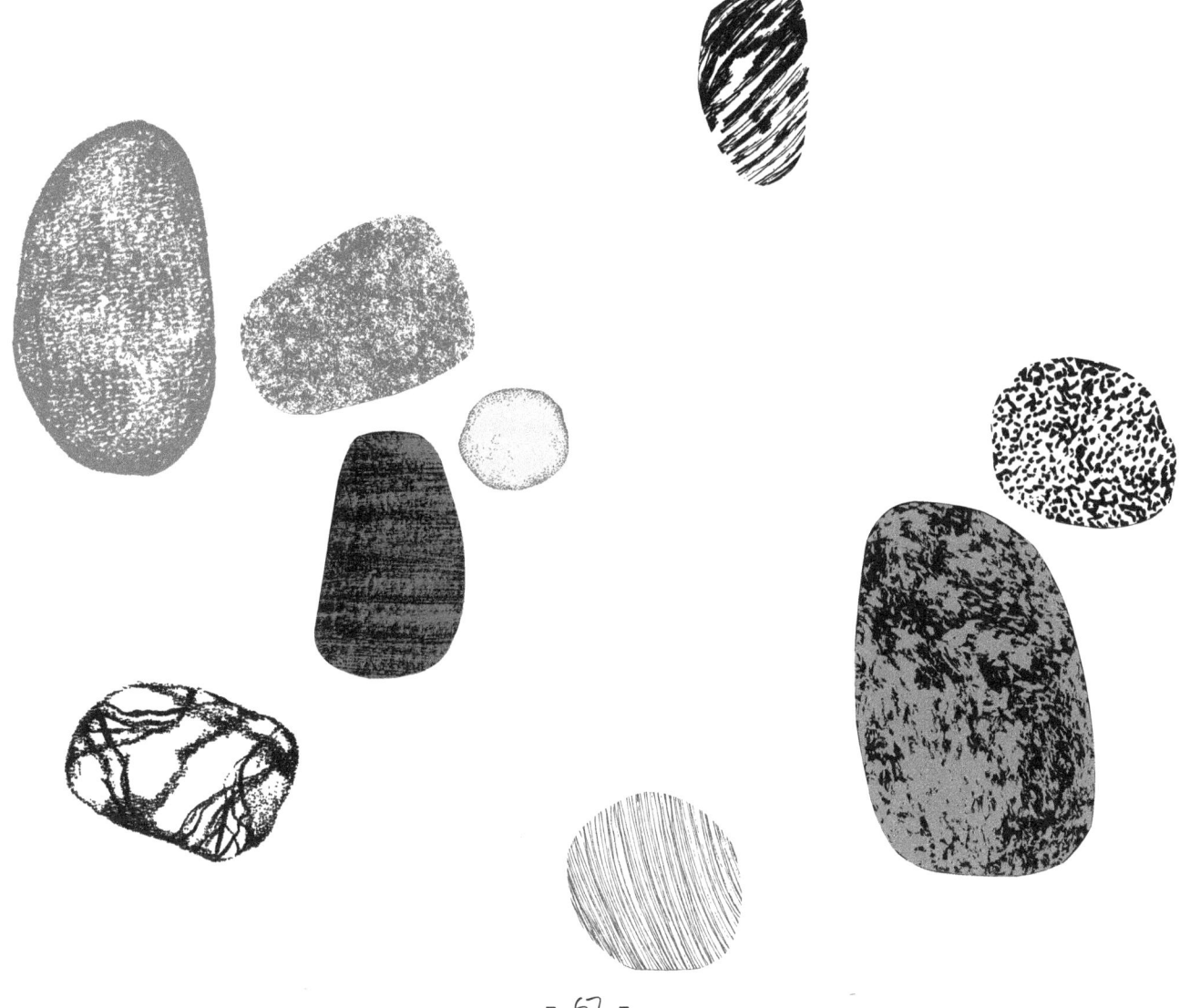

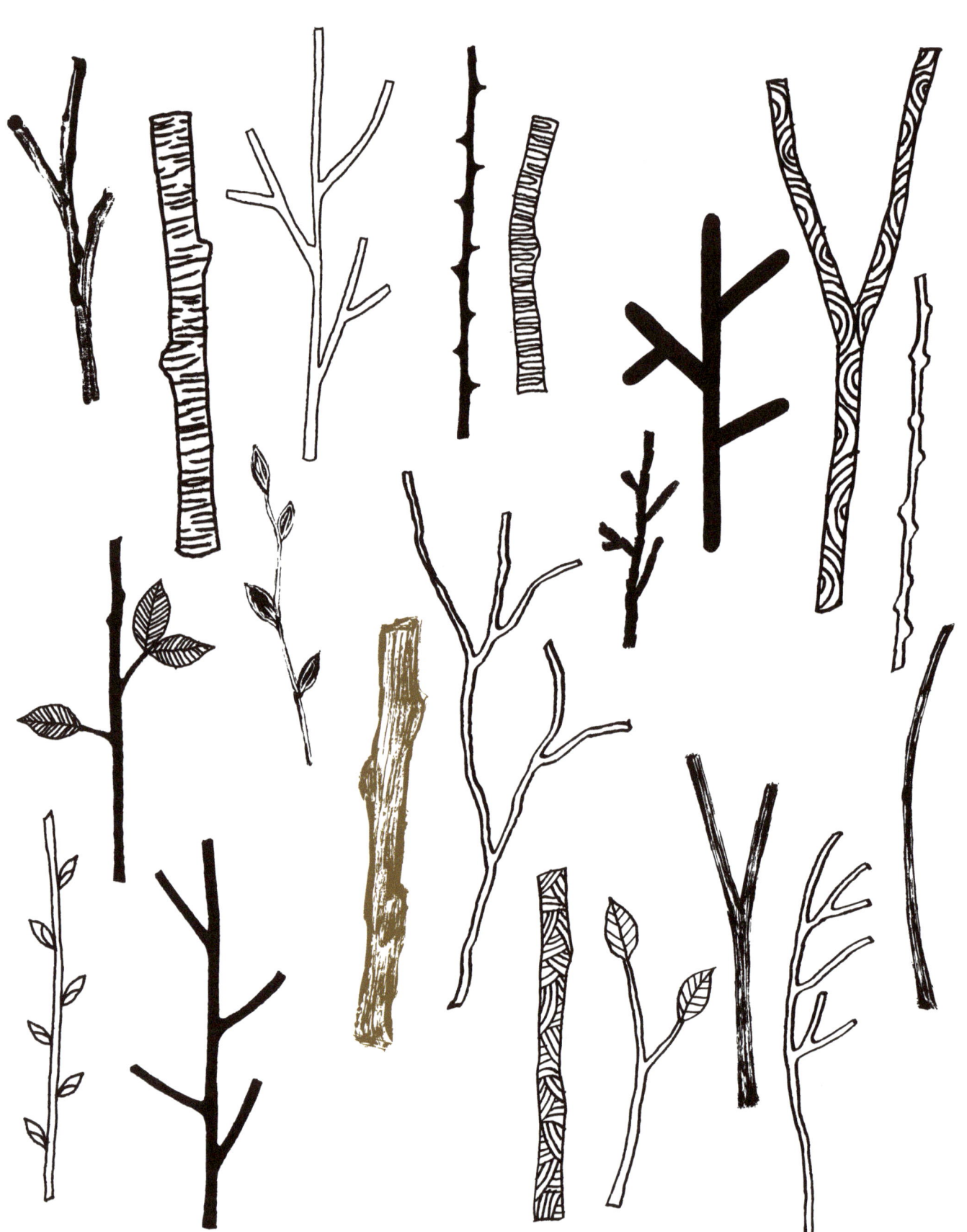

DRAW 20
TWIGS

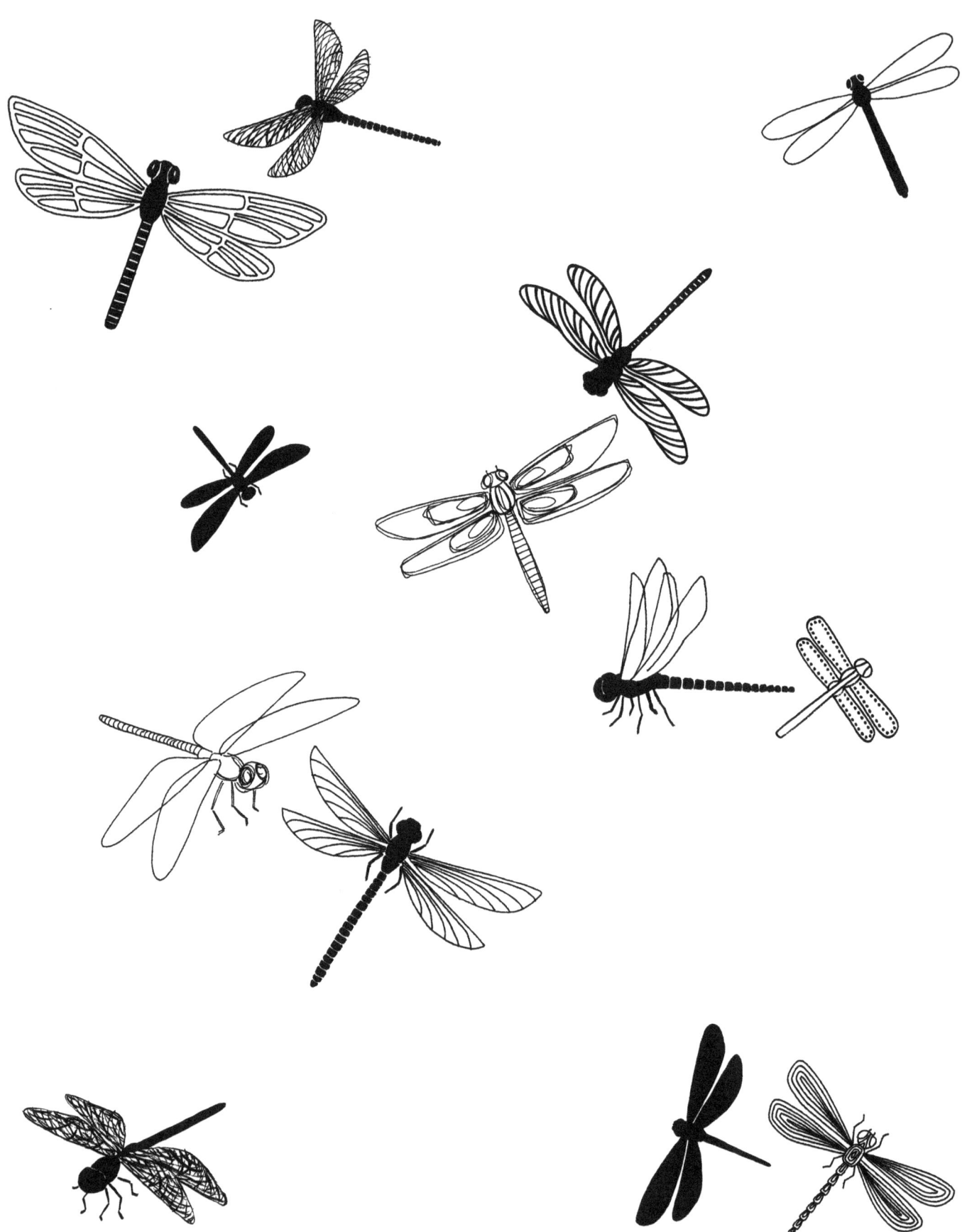

DRAW 20
Dragonflies

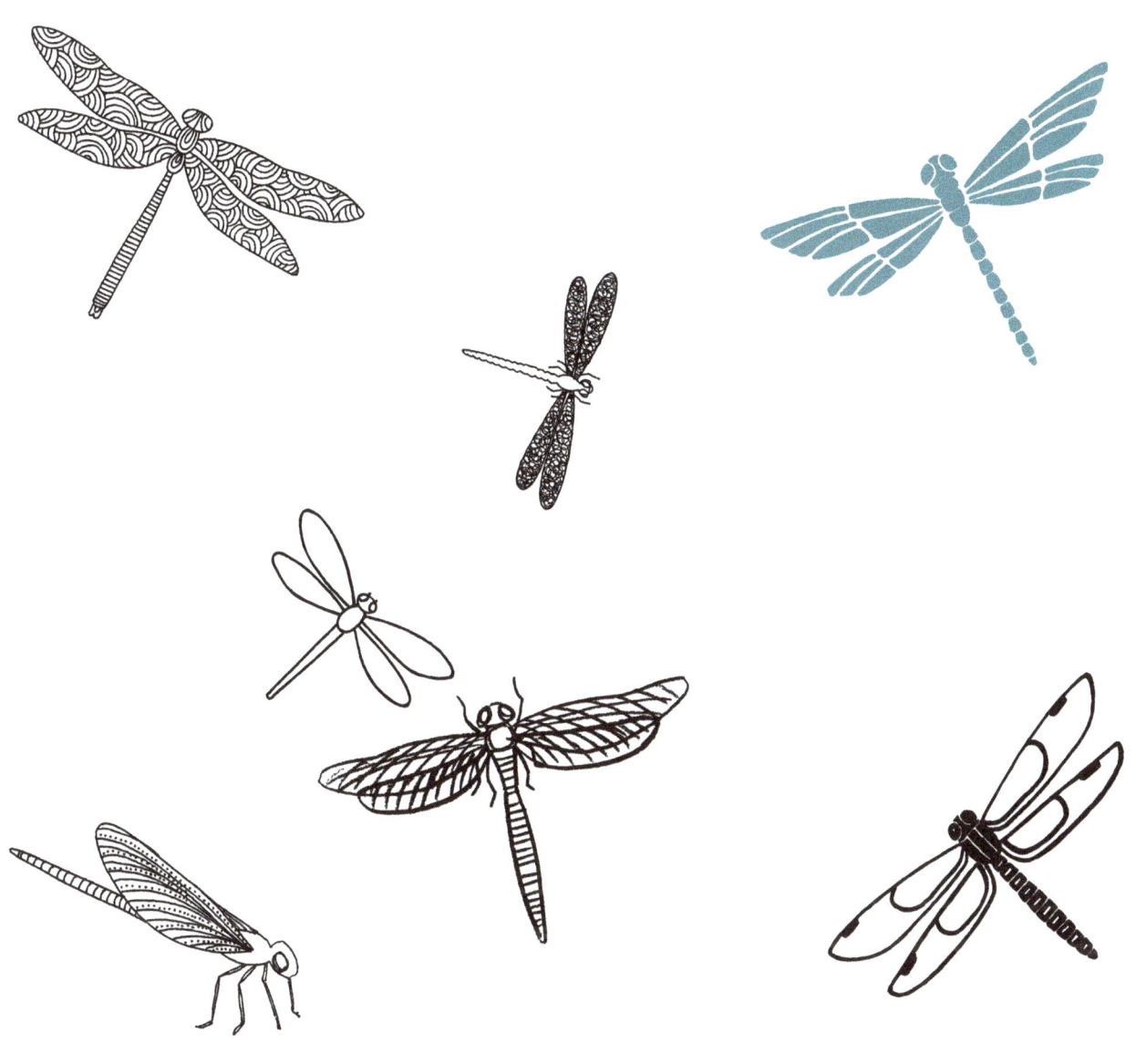

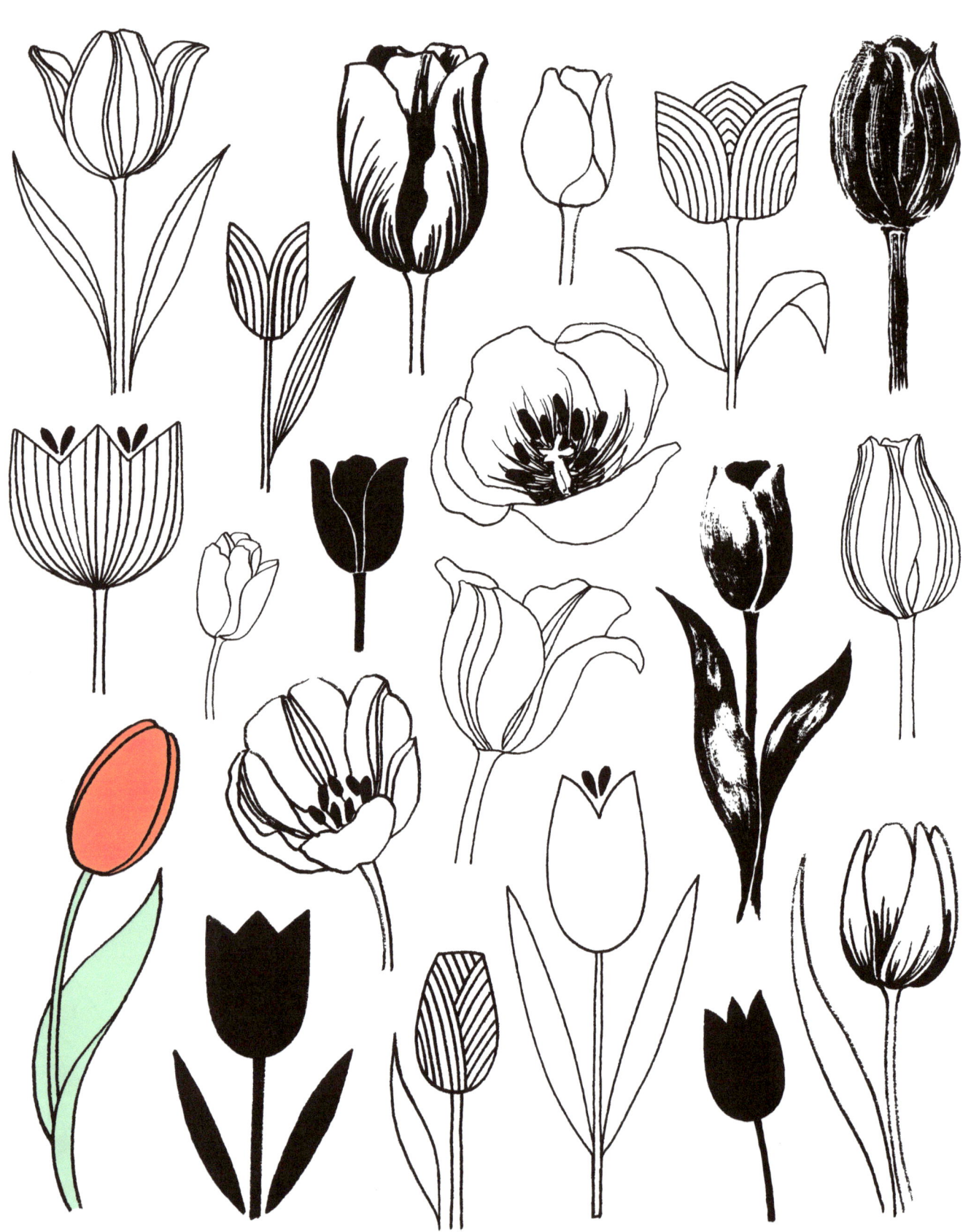

DRAW 20
Tulips

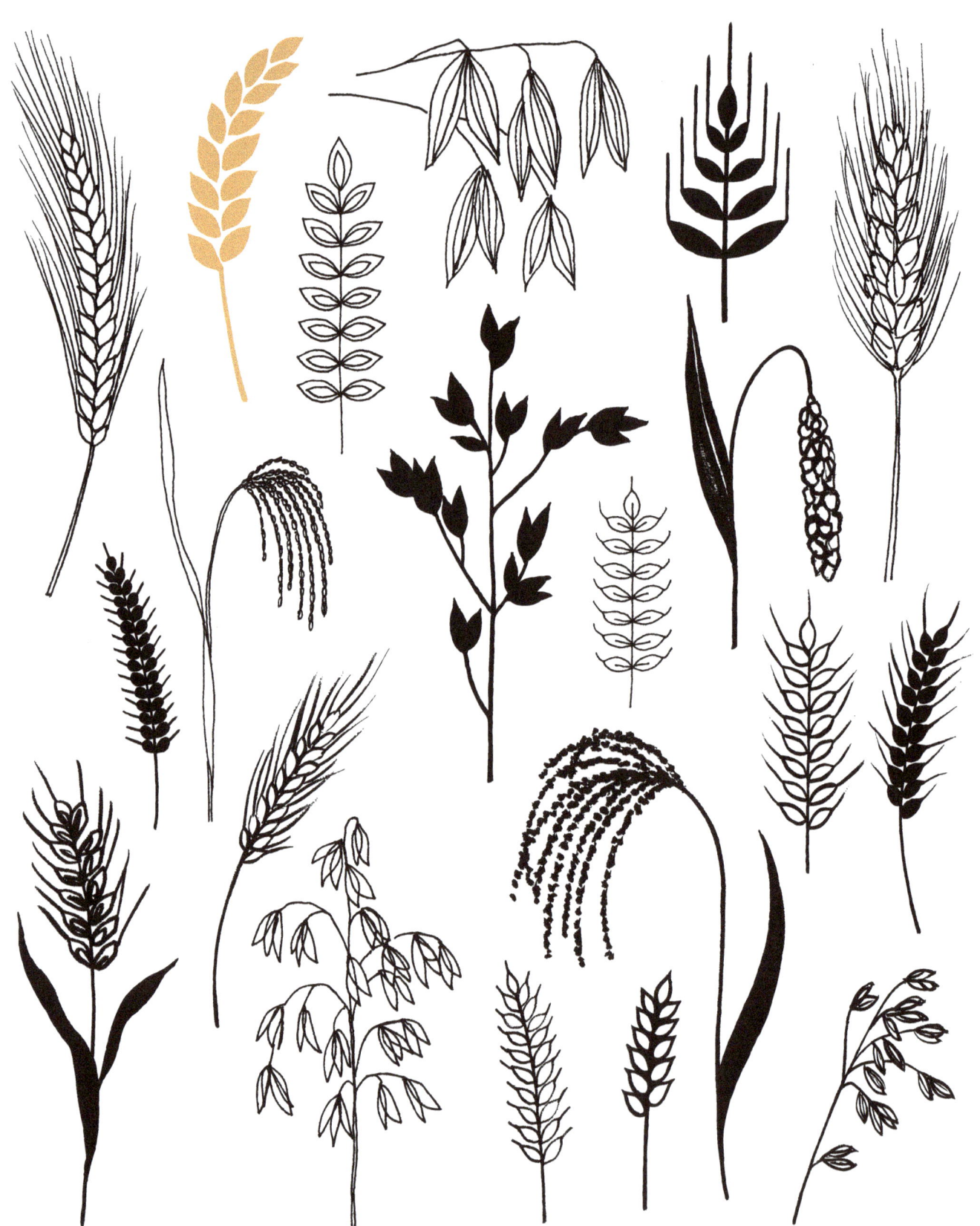

DRAW 20
GRAINS

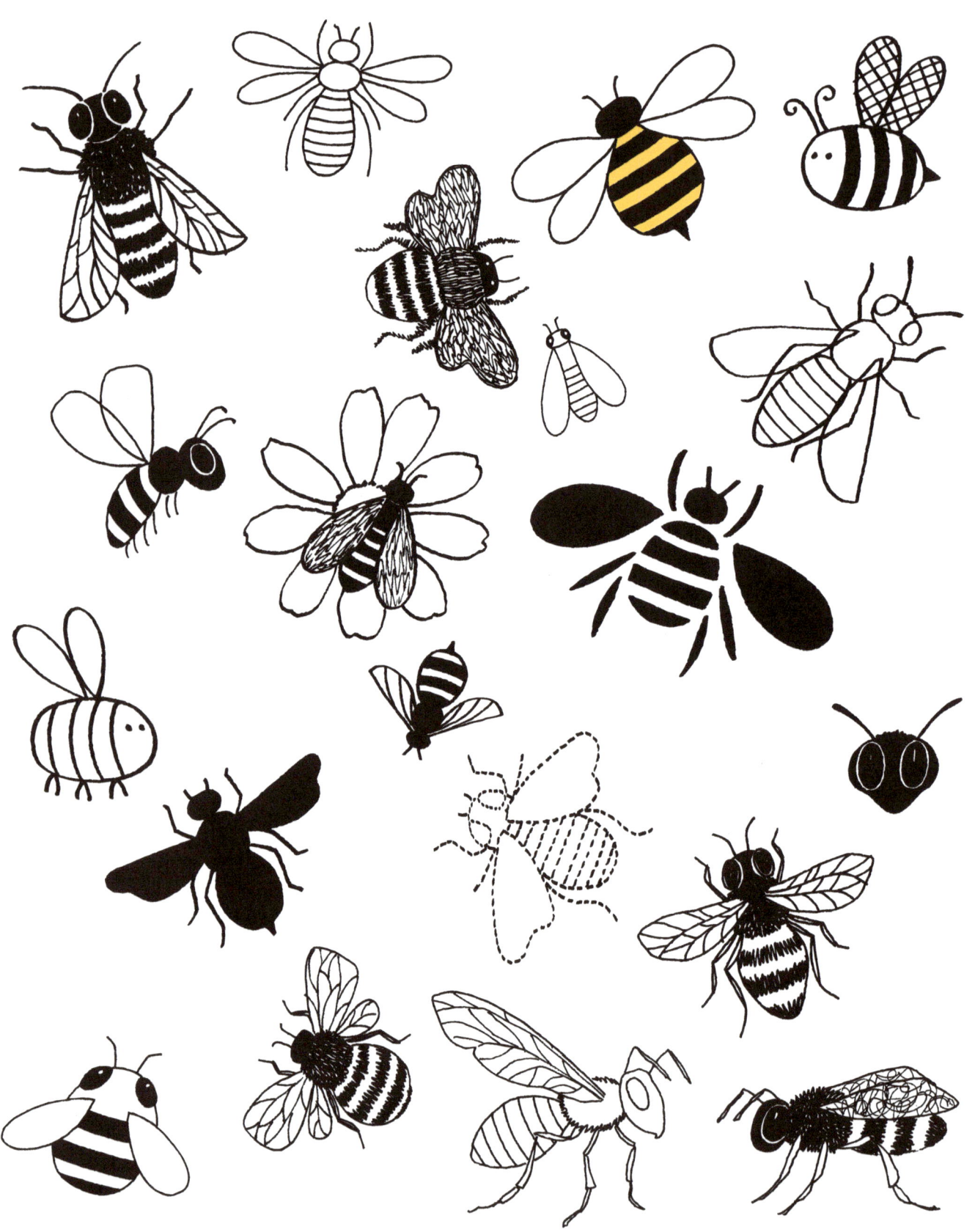

DRAW 20 BEES

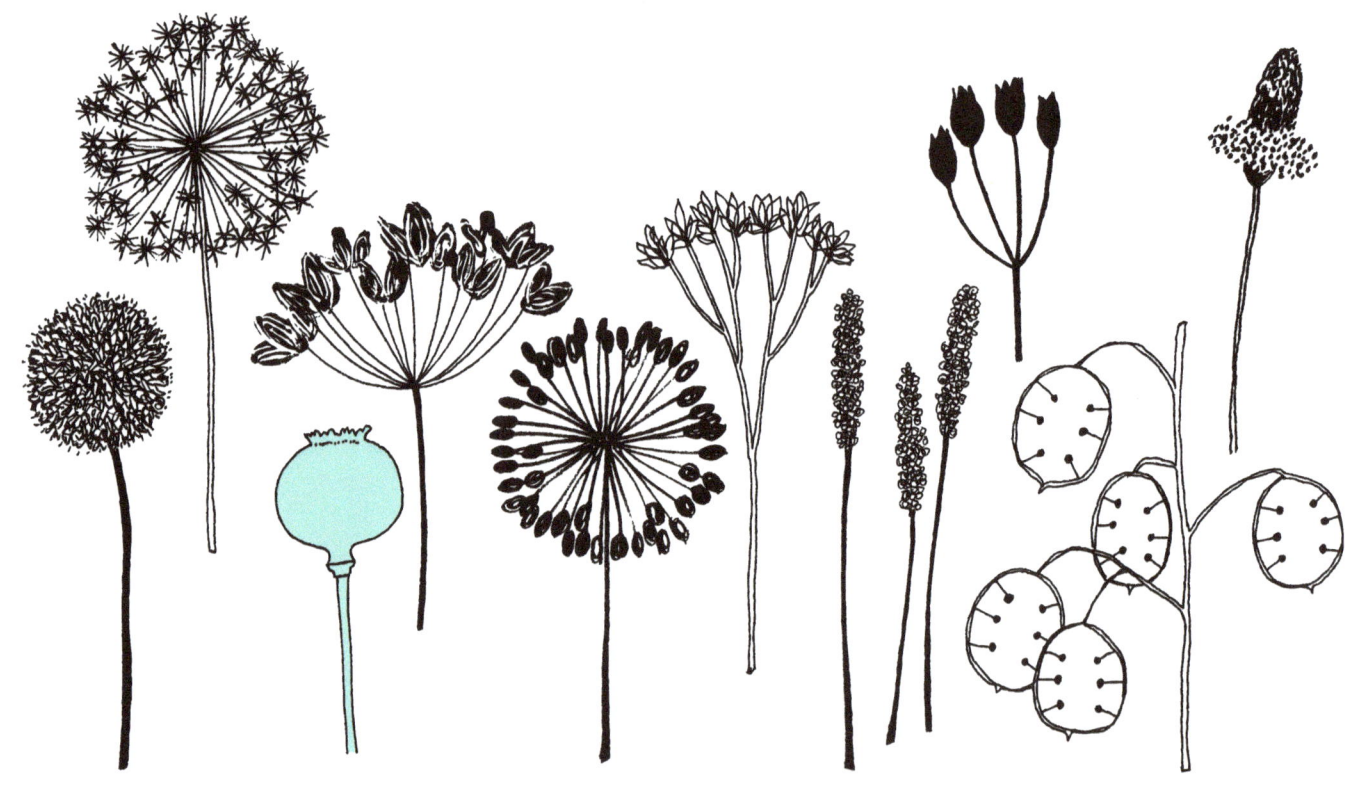

DRAW 20
seed heads

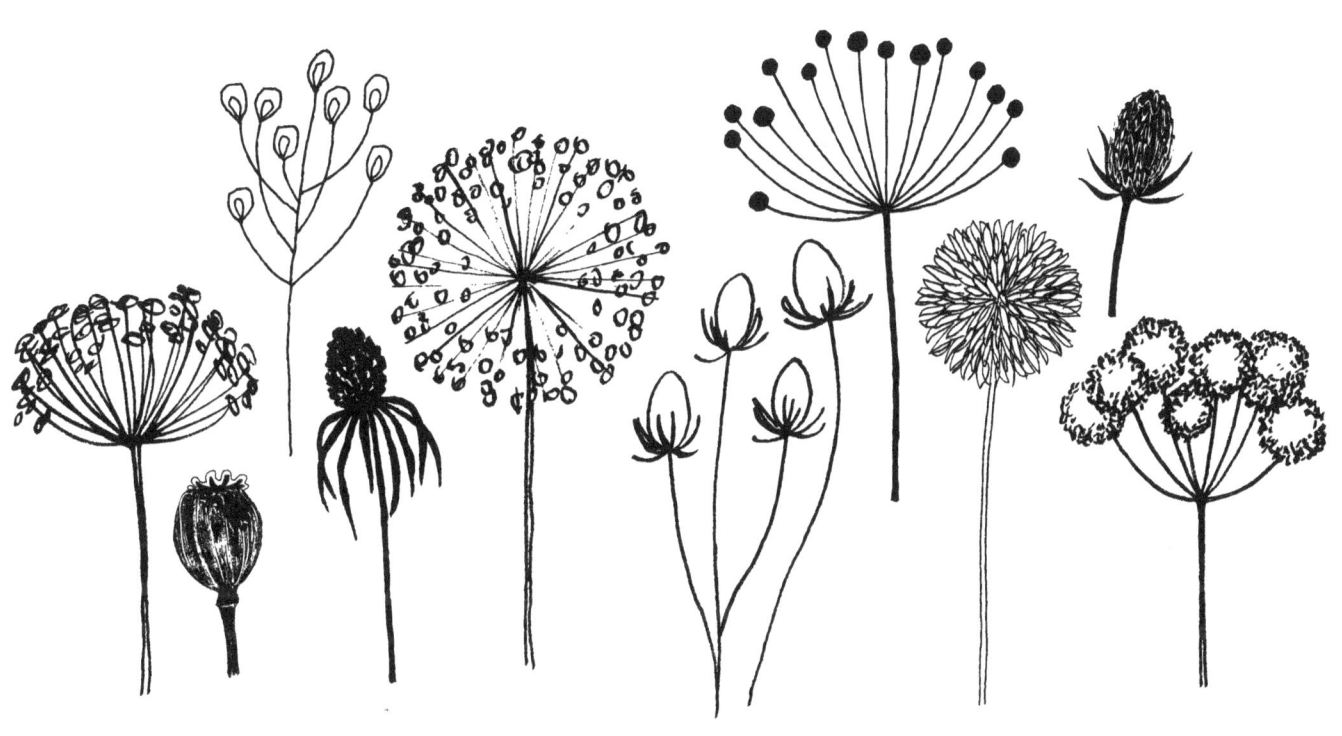

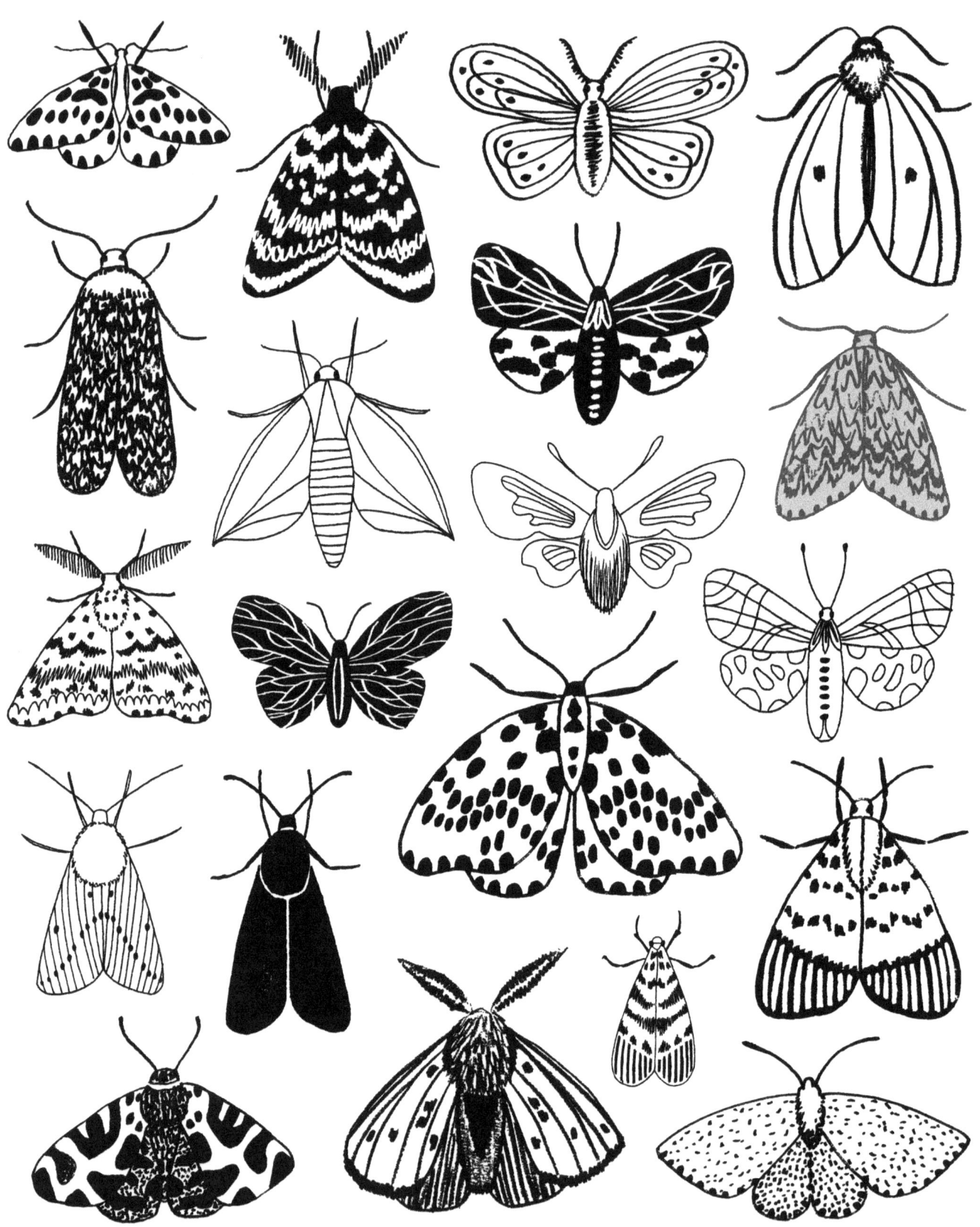

DRAW 20
MOTHS

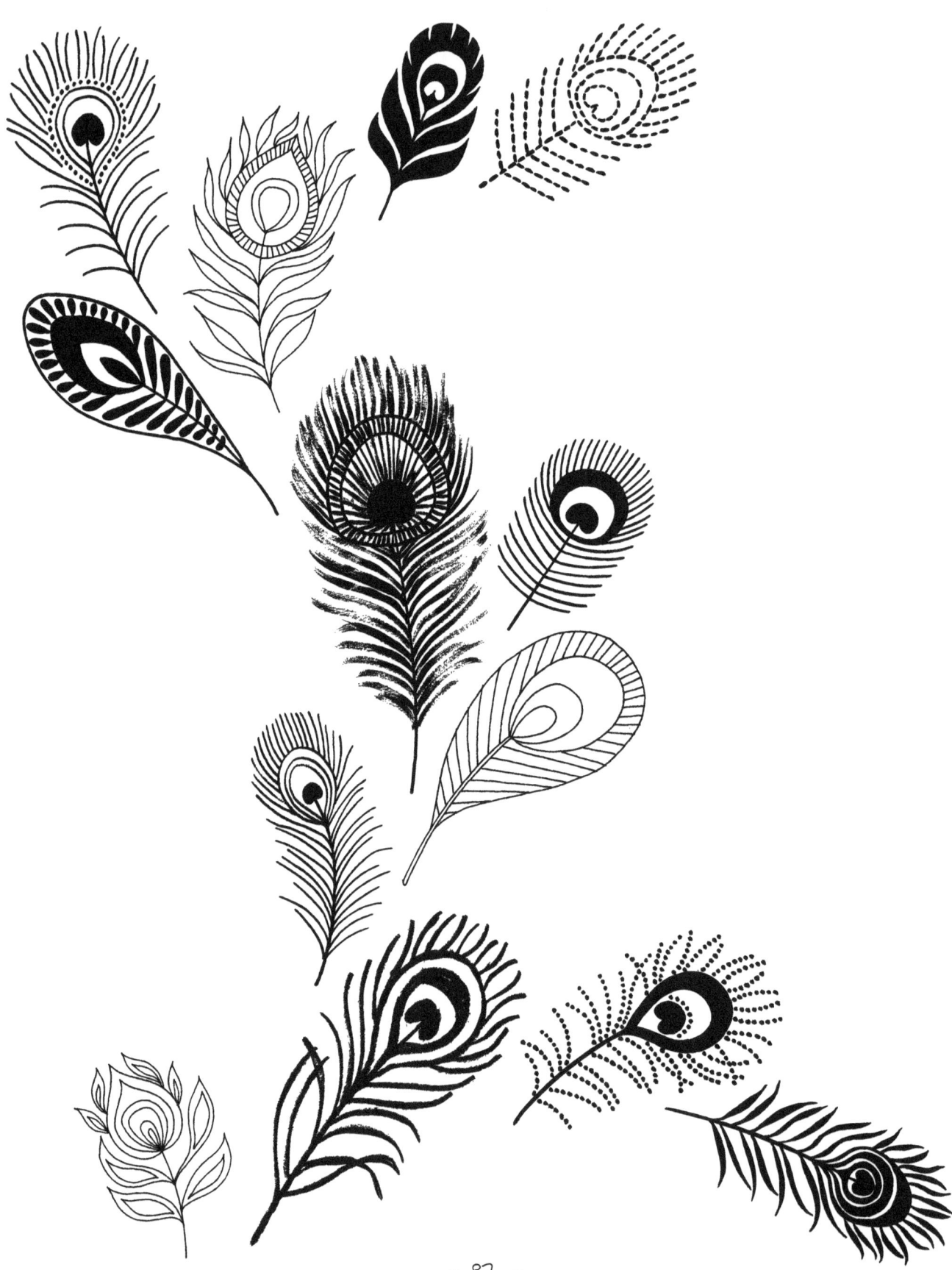

DRAW 20
PEACOCK FEATHERS

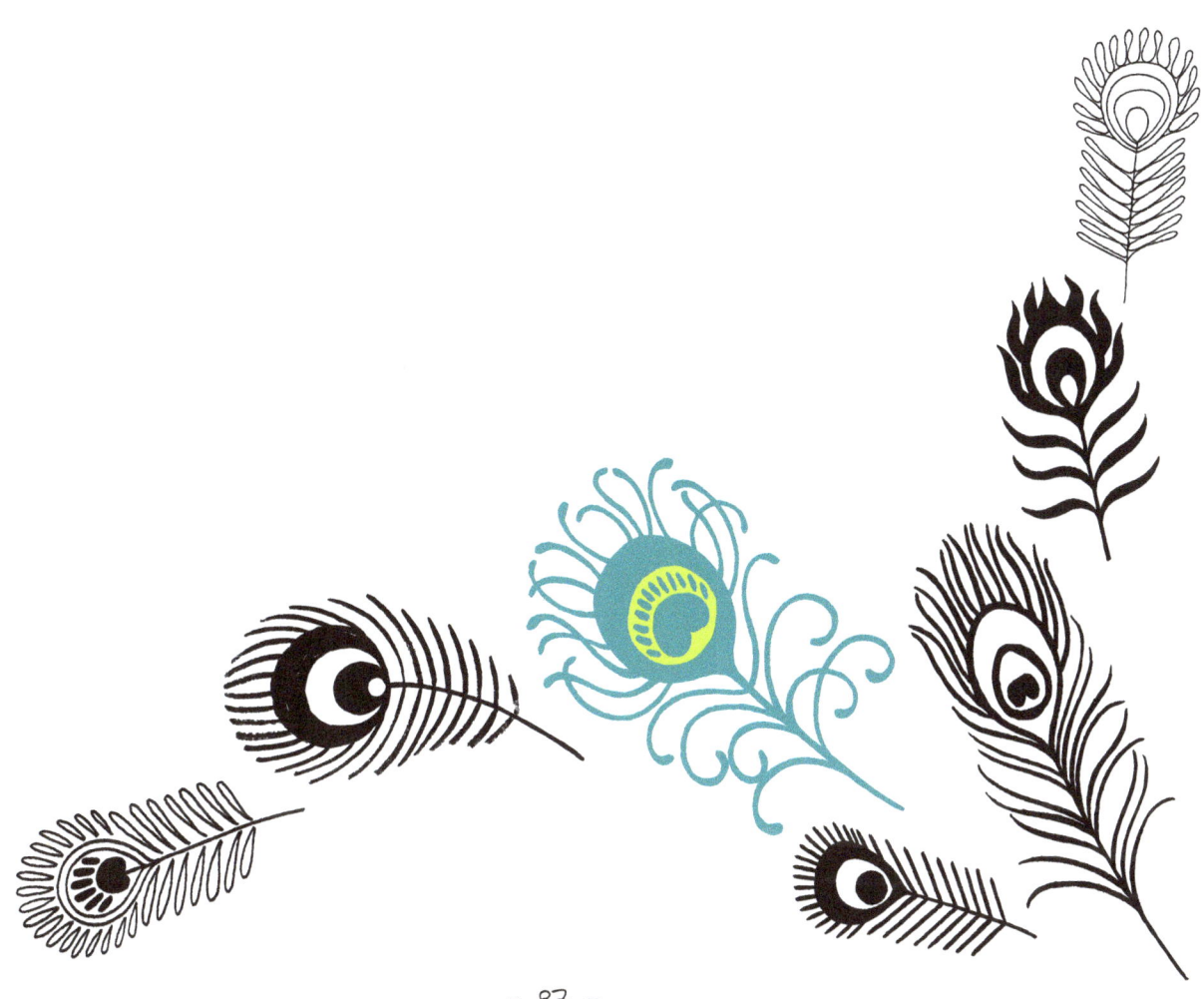

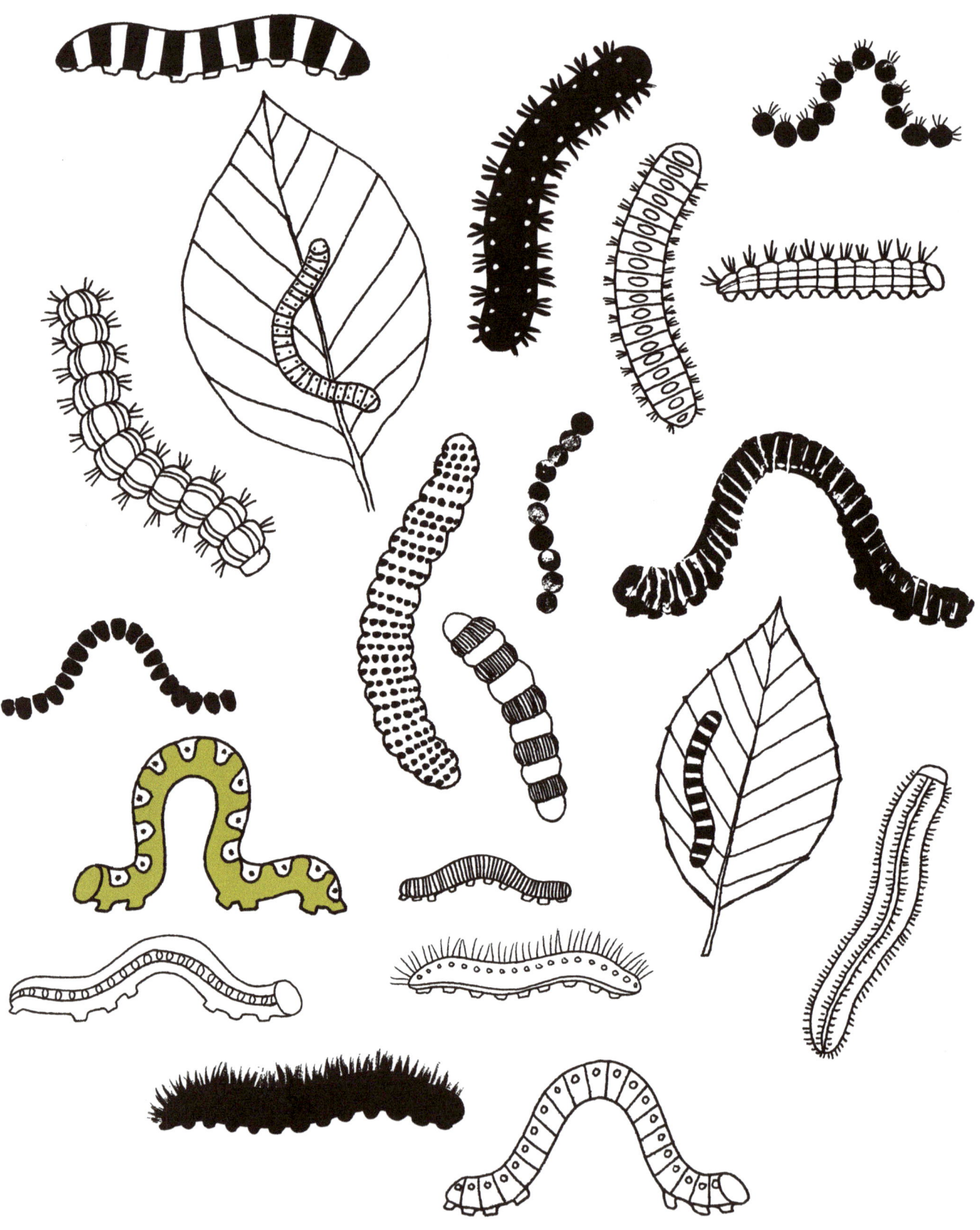

DRAW 20
caterpillars

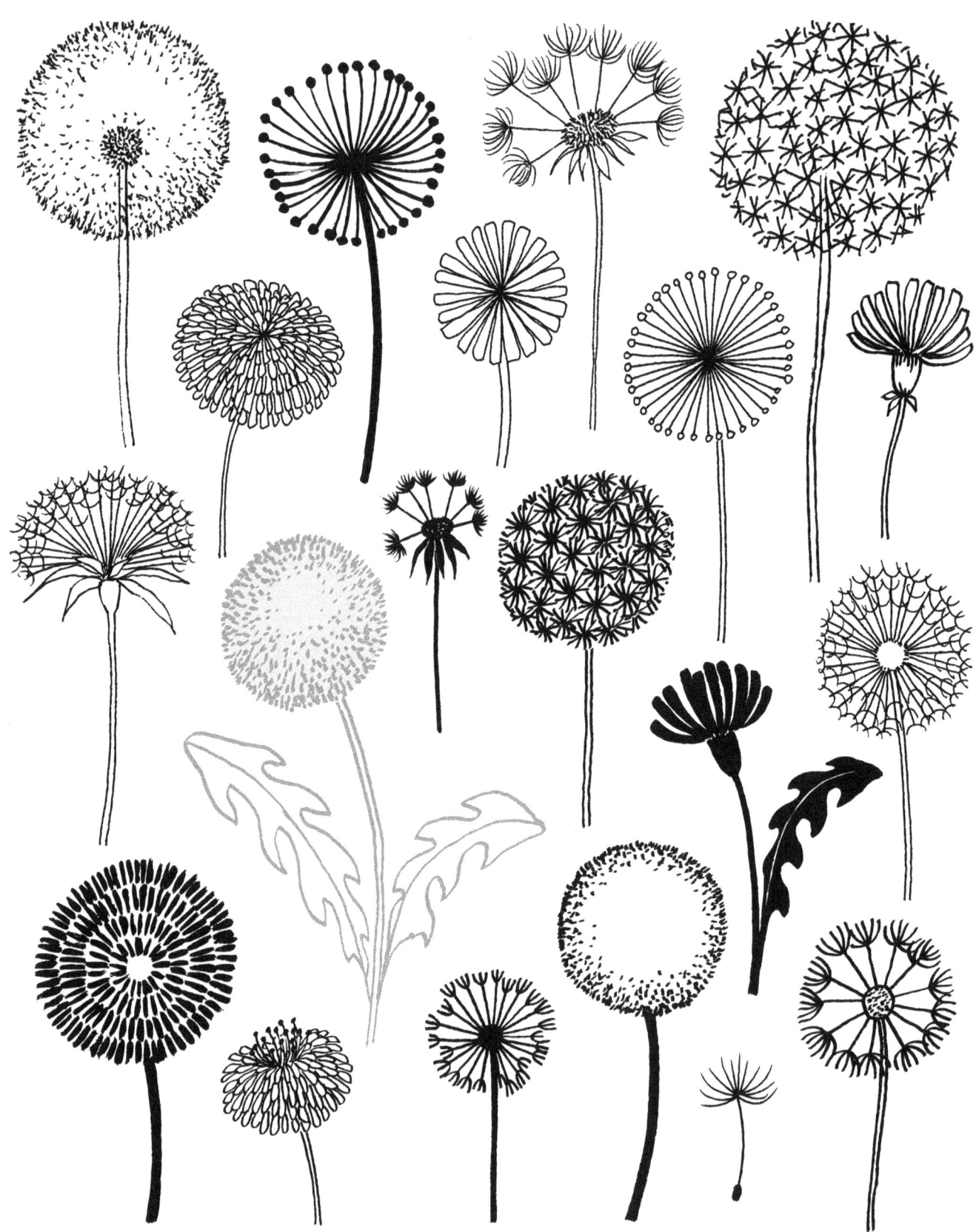

DRAW 20
DANDELIONS

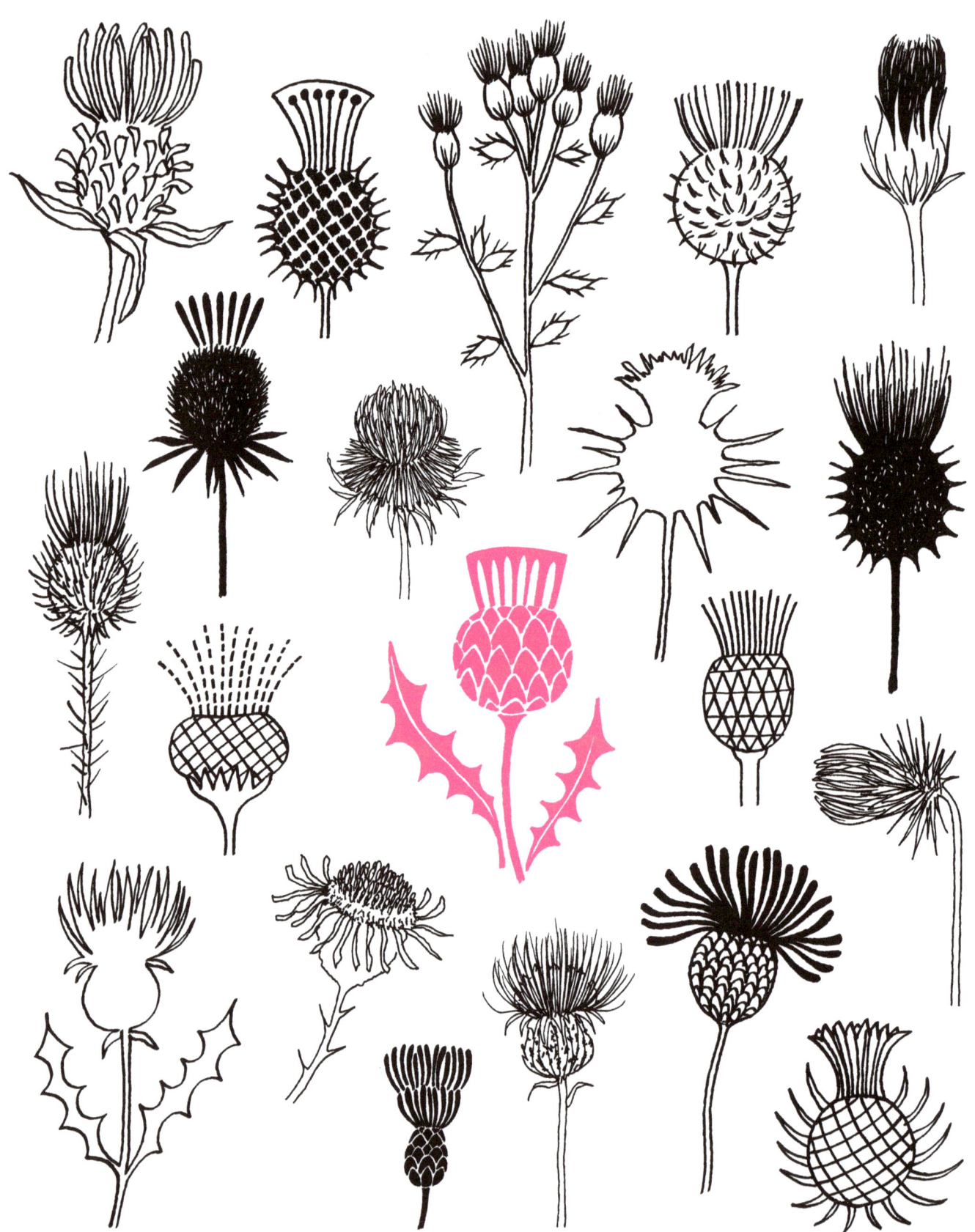

DRAW 20 thistles

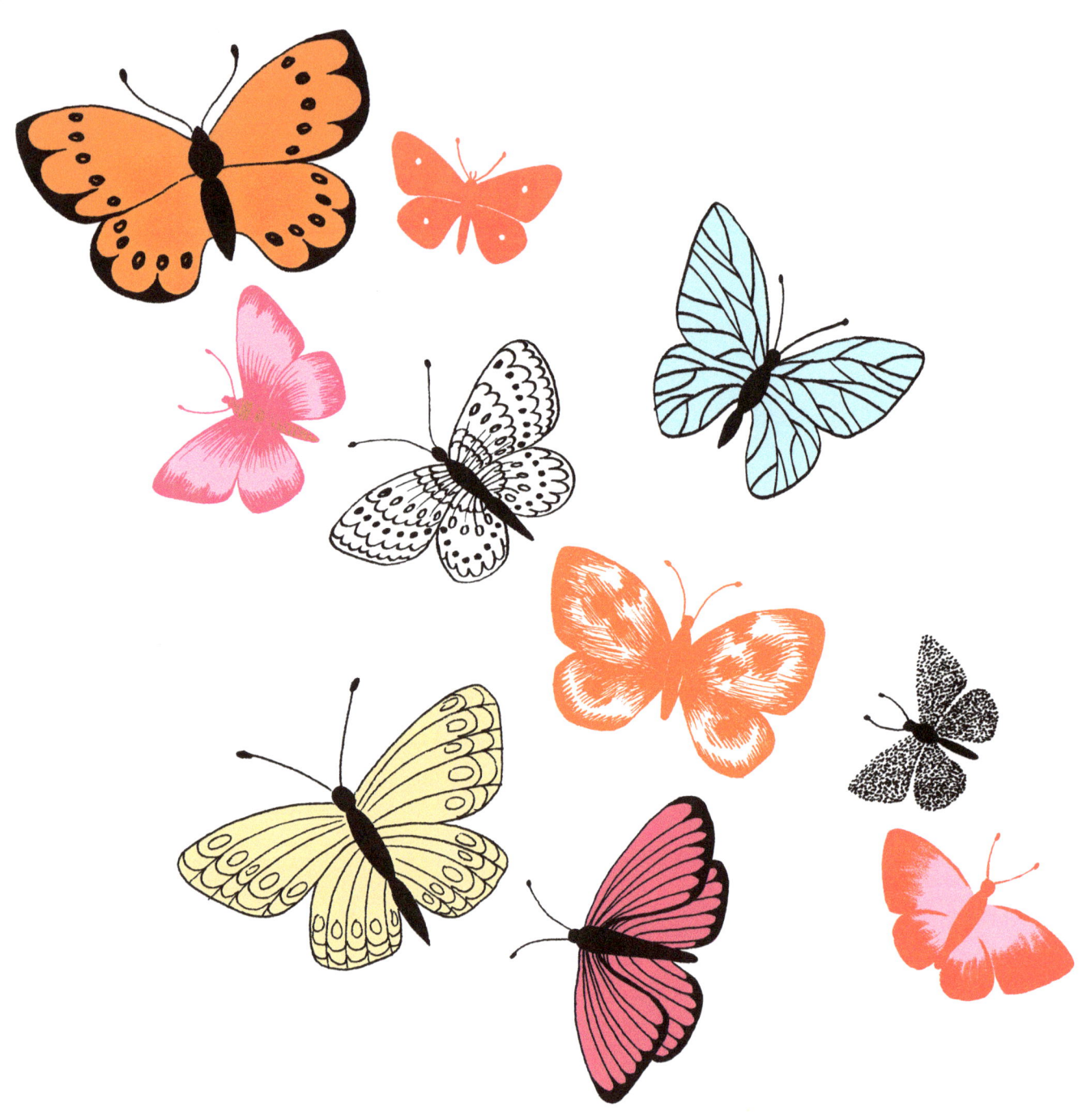

DRAW 20
butterflies

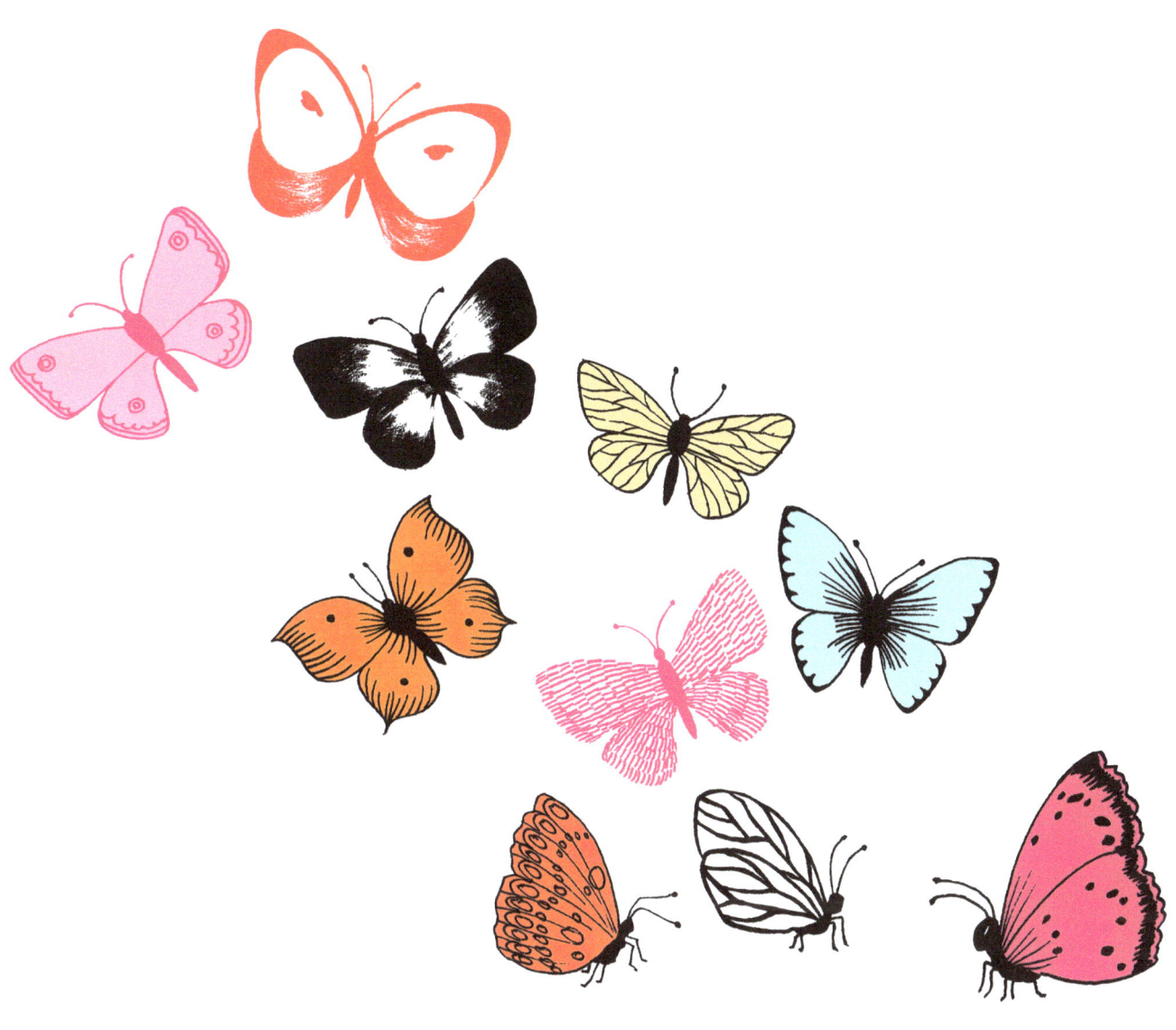

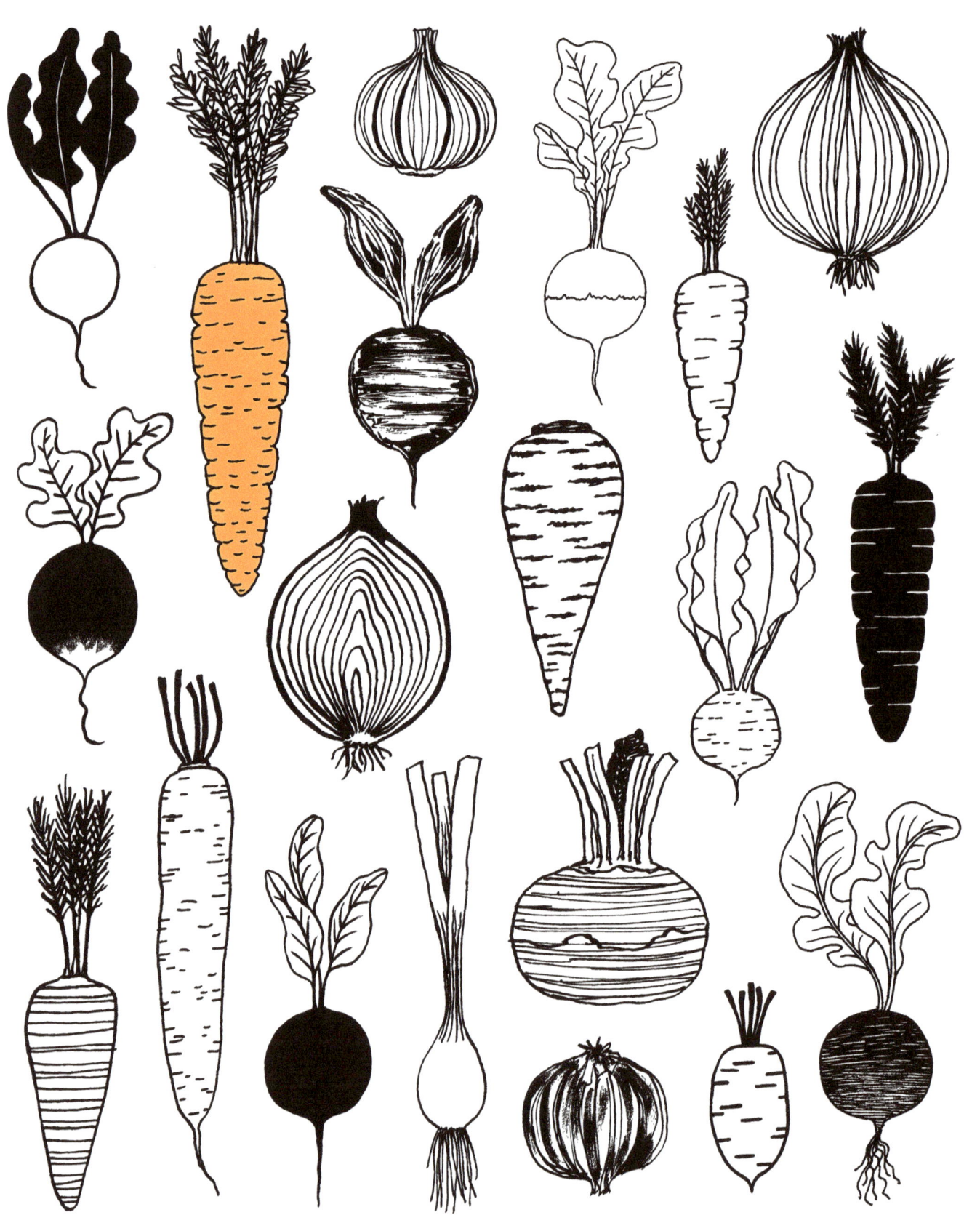

DRAW 20
root vegetables

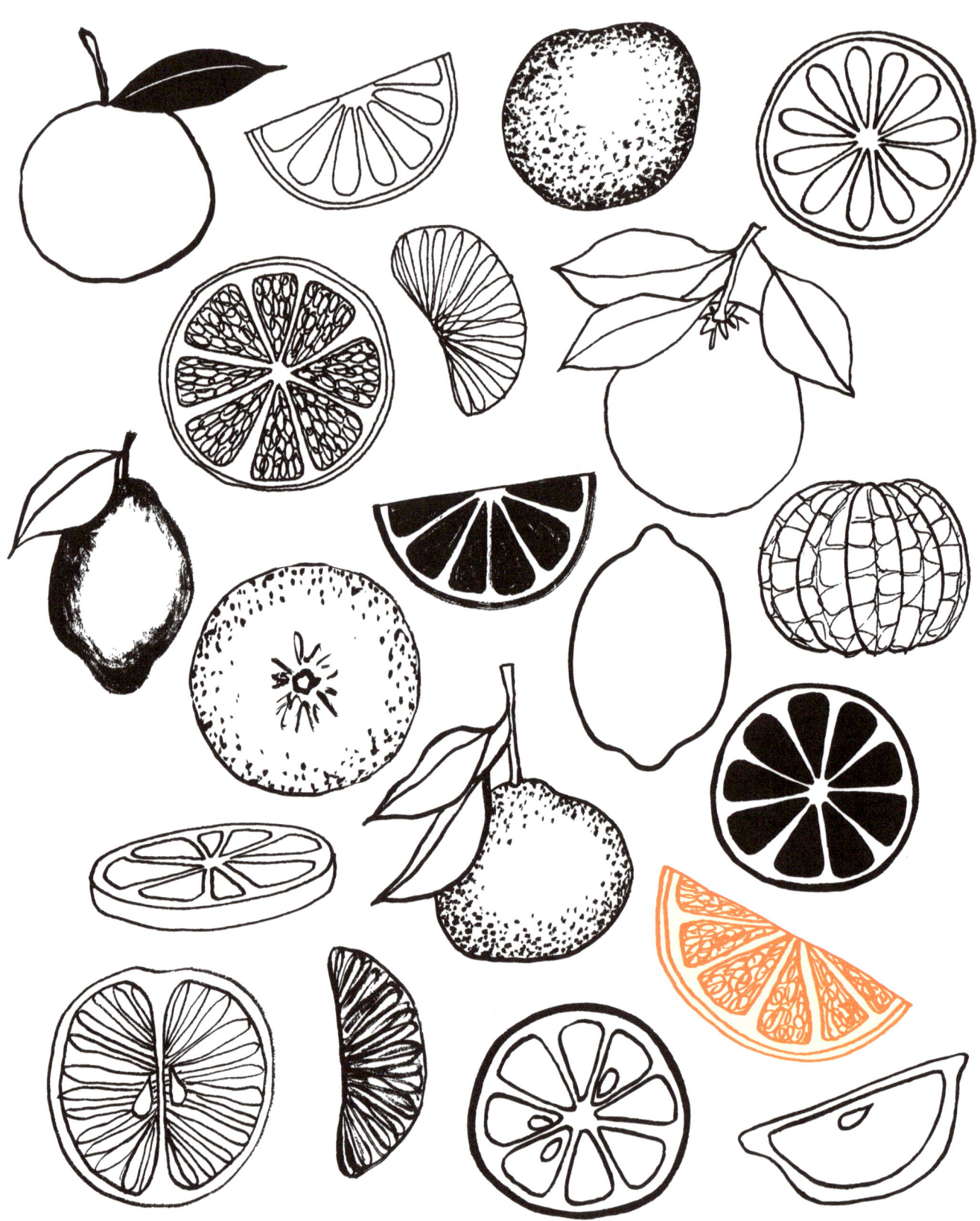

DRAW 20
citrus fruits

ABOUT THE ARTIST

Eloise Renouf graduated with a degree in printed textile design from Manchester Metropolitan University, UK. She worked as a fashion print designer in studios in both London and New York before establishing her own stationery company in 2000. She now designs and sells her own range of limited-edition prints and fabric accessories, whilst also undertaking commission and licensing work for homewares, stationery, and illustration. She lives and works in Nottingham, England, with her partner and three children. **www.eloiserenouf.etsy.com**

www.ingramcontent.com/pod-product-compliance
Lightning Source LLC
Chambersburg PA
CBHW041924180526
45172CB00014B/1378